IMAGES
of America

BUFFALO

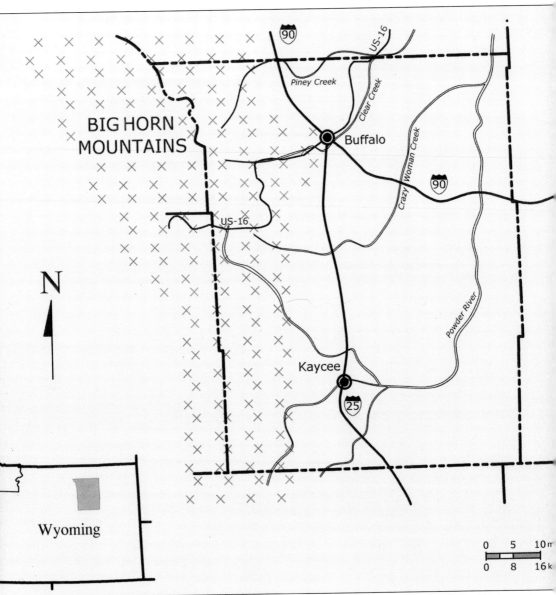

BIG HORN
MOUNTAINS

N

EARLY MAP. Pictured is a map of Johnson County, Wyoming. (Graphics by Bighorn Technical Design, Buffalo, Wyoming.)

IMAGES
of America

BUFFALO

Gil Bollinger and the
Jim Gatchell Memorial Museum

ARCADIA
PUBLISHING

Copyright © 2009 by Gil Bollinger and the Jim Gatchell Memorial Museum
ISBN 978-0-7385-6909-3

Published by Arcadia Publishing
Charleston, South Carolina

Printed in the United States of America

Library of Congress Control Number: 2008942872

For all general information contact Arcadia Publishing at:
Telephone 843-853-2070
Fax 843-853-0044
E-mail sales@arcadiapublishing.com
For customer service and orders:
Toll-Free 1-888-313-2665

Visit us on the Internet at www.arcadiapublishing.com

Dedicated to Buffalo's Centennial Book Committee and their
1984 publication, Buffalo's First Century. The committee
members were William C. Holland (chairman), Barbara Fraley,
Vera Buell, Charles K. Lawrence, and Patty Myers. Their
excellent book served as the primary reference for this work.

CONTENTS

ACKNOWLEDGMENTS

The photographs depicted herein were obtained from local sources, giving this pictorial history a true grassroots origin. Those sources were, in addition to the coauthor, the Jim Gatchell Memorial Museum, the Johnson County Library, the *Buffalo Bulletin*, and the Occidental Hotel and Museum. The staffs at each of those institutions could not have been more helpful or cooperative. In particular, the museum's director John Gavin, educator Bob Edwards, and registrar Sylvia Bruner; the library's director Cynthia Twing, history librarian Nancy Jennings, and staff member Megan Herold; the *Bulletin*'s publisher Susan Carr; and Occidental Hotel owners John and Dawn Wexo, with their information technology director Brian Humphrey, all made substantial contributions from their superb collections. We are in their debt.

Any treatise on local history should be reviewed for accuracy by local historians. This work benefited from excellent reviews by Nancy Jennings, Bob Edwards, John Gavin, and Patty Myers. Their essential contributions are much appreciated.

For brevity, the following abbreviations will be used for the four photograph sources in the credit lines:

Buffalo Bulletin newspaper—BBN
Jim Gatchell Memorial Museum—JGMM
Johnson County Library—JCL
Occidental Hotel and Museum—OHM

INTRODUCTION

Buffalo, Wyoming, is a special place. A community, just as an individual, can exhibit a presence that is difficult to explain but easy to feel. Many first-time visitors to Buffalo sense that quality and are surprised by their response to such a small town.

Certainly an element in Buffalo's being special is its location at a mountains-plains interface. With the snow-capped Big Horn Mountains on the west and the northern High Plains to the east, the physical setting is extraordinary. The scenery is beautiful and the climate invigorating. Clear Creek flows down from the Big Horns though the center of town. That cold, pure stream provides Buffalo residents with water and is habitat for rainbow and brown trout.

The particular combination of topography, scenery, and water at Buffalo has attracted humans since the earliest times. Native Americans lived in the general area for millennia. There is a tepee ring—a circle of stones that Native American women used to secure the base of the tepee covering to the ground—along a walking path within the city limits. Those stones would be left behind when the tepee was moved, perhaps to be used again in the future. Their presence in Buffalo is a direct link with the nomadic Native Americans. The earliest white men to visit may have been French-Canadian fur traders in the mid-1700s, but Francois Larocque and a companion definitely camped in the Buffalo locale in 1805. His detailed journal is explicit about locations. Larocque was followed by a succession of explorers, mountain men, and miners over the ensuing decades. They were attracted by those essentials items in a semiarid climate—pure water, good grass, and sheltered camping sites.

Another factor contributing to Buffalo's being different is its turbulent frontier heritage. The occurrence locally of multiple Indian War battles and a Cattle War has resulted in Johnson County being called an "Epicenter of Frontier History." The Native American conflicts were the Red Cloud War along the Bozeman Trail from 1865 to 1868 and the Plains Indian Wars in Wyoming and Montana during the mid- to late 1870s. No less than four military forts were built within the eventual county boundaries during those wars. In 1892, a shooting war developed between "cattle barons" and the small ranchers and homesteaders. That primarily county-level civil war left a long-lasting, emotional legacy with the Johnson County residents. Its saga would, with time, become a prototypical Western conflict for the Hollywood and television media.

The community of Buffalo developed at the eastern boundary of Fort McKinney (1877–1894) to provide services and materials to that garrison. The fort, in turn, provided markets as well as protection from the Lakota and Cheyenne at the start of their reservation era. In addition to causing an "army town," Fort McKinney also fostered the development of ranches and farms in the surrounding area; in other words, it was indeed a regional economic catalyst.

In 1869, the Wyoming Territory was formed, and its first legislature began the lengthy process of setting up a county structure. Johnson County was authorized in 1875, but adequate population levels delayed its actual establishment until 1881, with Buffalo as its county seat. In 1884, Buffalo received a city charter and was platted for the first time. That initial legal definition of streets

and lots caused a great deal of difficulty for the several hundred residents. All of the business buildings and homes had been built where the owner chose with no thought to land ownership. That practice was usual at the time in remote western frontier areas. Real estate ownership would develop subsequently, usually as a community project, with no major problems. However, a new commandant at Fort McKinney was an opportunist. Maj. Verling Hart arrived late in 1878 and promptly filed a Desert Land Act claim for the land immediately adjacent to the east boundary of the fort's military reservation—exactly where fledgling Buffalo was sited. Hart died unexpectedly in 1883, and his federal claim was awarded the following year to his widow, Juliet Hart. By that time, 1884, the Buffalo tax rolls listed 242 names. When Juliet Hart had the platting survey started, it was clear to the town's residents what her intentions were. They petitioned the federal government to rescind her land patent but were unsuccessful. The entire Buffalo community then became squatters and would have to deal with Hart for the land they were occupying. Deal they did. The Johnson County Deed Records show some 250 land sales during the next few years, including one for $512 to the county commissioners for a courthouse site. It had to have been an interesting experience for Juliet Hart to suddenly "own" an entire town.

The availability of both homesteading and open-range grazing on federal lands added to the attraction of this portion of the Powder River drainage basin. It also fostered two very different land uses and operational scales in the same region—large ranches using open-range grazing and individual homesteads for farming or small ranches. Those differences and hubris eventually led to the aforementioned 1892 Cattle War. The hubris was exhibited by the Wyoming Stock Growers Association, a group of wealthy ranchers who "invaded" Johnson County with a large group of hired Texas gunmen. Their intent was a vigilante-type action against the small ranchers they contended were stealing their cattle and fencing off water sources. The invasion came to a climax with a protracted gun battle at the TA Ranch, some 13 miles south of Buffalo. Soldiers from Fort McKinney intervened and arrested the invading cattlemen and their hired killers. Those arrested were taken to Cheyenne for trial but were eventually released. Justice was never completely served in this instance.

Following the trauma of the Cattle War, Buffalo and the surrounding area began a period of sustained growth and development. Early progress was based on the rapid expansion of cattle and sheep ranching and of irrigation farming. Sheep had come early to Johnson County, and the cattlemen soon learned that both could be raised to financial advantage with proper range and grazing management. Soon after the dawn of the 20th century, Basque sheepherders were recruited and quickly became an essential part of the community. The large areas needed for effective irrigation systems usually resulted in cooperative ventures by neighboring farmers and ranchers. Sugar beets, grains, and hay were the major crops grown. Mining, principally for coal, and lumbering in the adjacent Big Horns developed and would round out the local economy. With time, advances in communications and transportation brought Buffalo and its environs into the modern era. Dude ranching and tourism then developed to the point that they are now important sources of local income. The *Casper Star-Tribune*'s Sunday "Discover" series article on October, 26, 2008, stated, "Buffalo is a gateway community to the Big Horn Mountains. Situated on two interstates [I-25 and I-90], it's easy to get to. It's a true mountain town with plenty to see and do."

Buffalo remains a small community with a current population at the 4,000 level. The sense of history there is almost palpable. Read on and see if you don't agree.

One

THE FORT, THE TOWN, AND THE LADY

1878 TO 1885

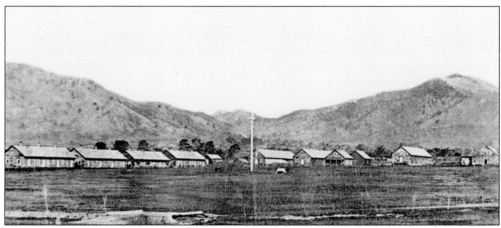

EARLY FORT MCKINNEY. This early-1880s photograph is the earliest known picture of the fort. Sited in 1878 on the eastern flank of the Big Horn Mountains, the post at this time had some 30 buildings and a military garrison of 250 to 300 cavalry and infantry. The fort was established to monitor for Native American activity off the reservations in adjacent Montana and South Dakota, and to provide deterrence against any hostility. The specific site for the post was selected because of the excellent water quality from Clear Creek that ran through the grounds and the nearby source of lumber on the Big Horn slopes. The early growth of Buffalo provided a wide range of workers and craftsmen along with food supplies in support of the military personnel and their livestock. (JGMM.)

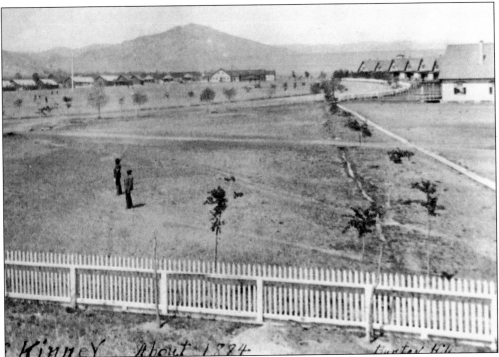

FORT MCKINNEY PARADE GROUNDS. These pictures of the fort's parade grounds are dated around 1884. The views are to the west. The photograph above was probably taken from the post hospital at the eastern edge of the fort's building complex; its picket fence is seen in the foreground. The curved road and line of houses at the mid-background right are officers' quarters and were referred to as "The Line." They formed the north boundary of the parade grounds. The Regimental Band is shown below assembled at the flagpole near the center of the parade grounds. That flagpole was distinctive in being especially tall and well made. Its maker, William Daley, had emigrated from the New England area, where he was involved in the construction of masts for sailing ships. The symmetrical peak seen on both pictures' horizons is North Ridge, which forms the north boundary for Clear Creek's exit from the Big Horns. (Both, JGMM.)

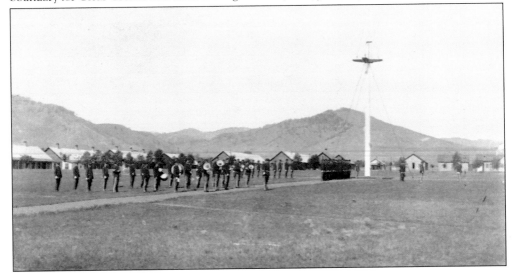

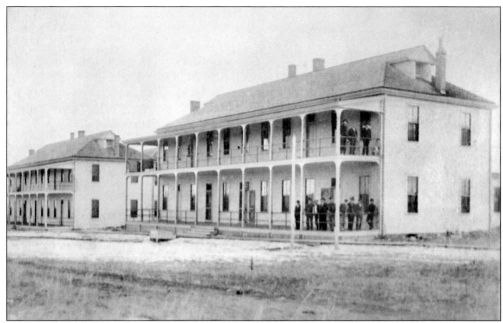

FORT McKINNEY BUILDINGS. For enlisted soldiers there were four barracks for the infantry and two for the cavalry. These structures were large, two-story buildings with two porches along one full side (pictured above). The barracks were located along the south side of the parade grounds. The hospital building (shown below) was the best-built structure on the post and probably the handsomest. Of the eventual 40-plus post buildings, it is the only one that has survived to the present day. After Fort McKinney was decommissioned in 1894 the federal government ceded it to the State of Wyoming. In 1903, the state made it the Soldiers and Sailors Home. The name was changed to the current Wyoming Veterans Home, and it continues in that function for the state's veterans. The hospital building now holds some state offices. (Both, JGMM.)

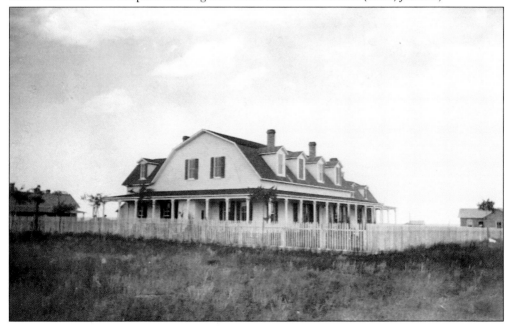

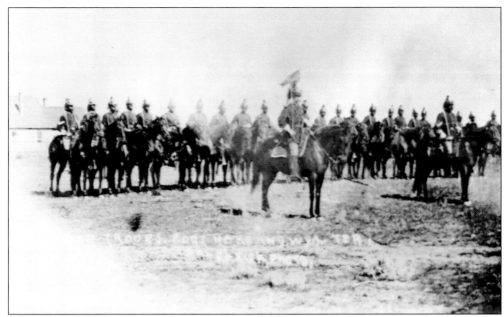

FORT MCKINNEY BUFFALO SOLDIERS. The famed Buffalo Soldiers were stationed at Fort McKinney between 1885 and 1894. There were up to five 9th Cavalry companies (pictured above) and 300 personnel present. Having that many African Americans coming into town on a regular basis was a new experience for the Buffalo residents. According to *Buffalo Bulletin* articles throughout the period, the two groups got along very well and seemed to enjoy each other's presence. Those soldiers participated in aftermath conflicts of the 1890 Wounded Knee tragedy in South Dakota. Following those engagements, their corporal, William O. Wilson, was awarded the Congressional Medal of Honor for gallantry. Inspections were, of course, a routine fact of life for both the Buffalo Soldier Cavalry and the Caucasian Infantry (shown below) at Fort McKinney. (Both, JGMM.)

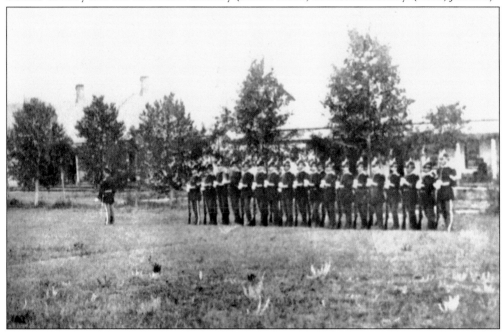

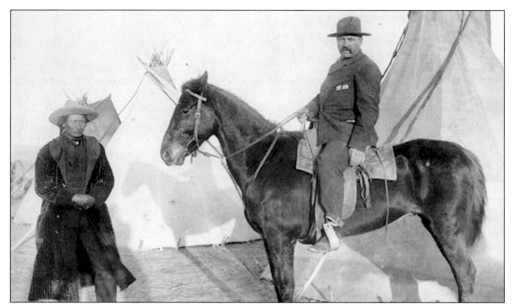

FORT MCKINNEY SCOUT. The famed frontier scout Frank Grouard (1850–1905) was listed on the 1880 fort census as a U.S. scout. He served there until its decommissioning and was also identified as a U.S. marshal during some of that time. This is Rocky Bear and Frank Grouard (on horseback). It is dated 1892 at an unidentified location. Grouard was captured by the Lakota as a young man. He escaped and went on to become the chief scout under Gen. George Crook during the Plains Indian Wars before serving at Fort McKinney. (OHM.)

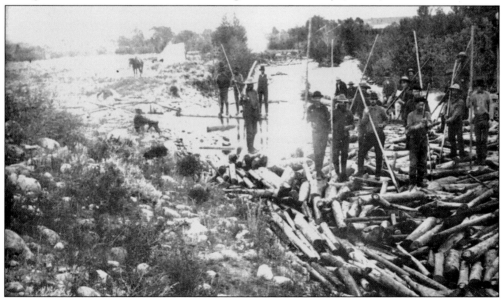

CORDWOOD FOR FORT MCKINNEY. This 1885 photograph shows logs destined to become cordwood. The civilian workers with long pike poles are Buffalo residents. Other services locals provided included skilled construction work, sawmill operation, freighting, and masonry. Supplies furnished were meat and vegetables for the soldiers and grains and hay for their horses. Total direct purchases and payrolls by the fort have been estimated at an annual $250,000, representing a substantial input during Buffalo's early growth years. (JGMM.)

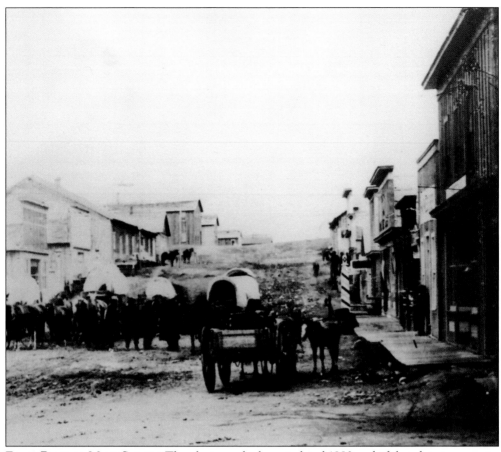

EARLY BUFFALO MAIN STREET. The photograph above is dated 1880 and, if that date is accurate, is the earliest image of Buffalo's Main Street available. The view is to the south and depicts considerable horse and wagon traffic, early wooden buildings, a dirt street, and a partial wooden sidewalk. The illustration below shows a number of oxen, apparently resting along the east side of North Main Street, in front of S. T. Farwell's tobacco and notions store. Perhaps a delivery has been made there. Farwell opened his store in 1881. Against the photograph's left edge is Robert Foote's General Merchandise store, which was located across the street from the present courthouse building. (Above, JGMM; below, OHM.)

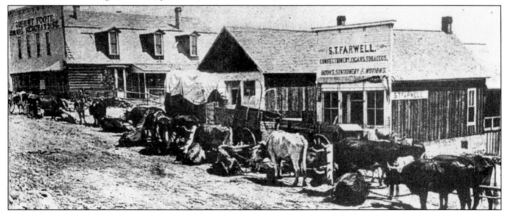

TRABING TRADING POST, 1878–1879. In 1878, August and Charles Trabing established a trading post and roadhouse on Crazy Woman Creek some 20 miles south of developing Buffalo. It was along the freighting route from Cheyenne to the Powder River forts that followed the earlier Bozeman Trail. As the first store in present Johnson County, it developed into an early community center. Near the end of 1879, the Trabings moved their business to the new town of Buffalo at a location adjacent to the present-day post office on South Main Street. That move had a beneficial effect in that it was a real vote of confidence in the fledgling community's future. The photograph below shows a long bull team hauling freight across the Crazy Woman Creek near the Trabing site. (Above, OHM; below, JGMM.)

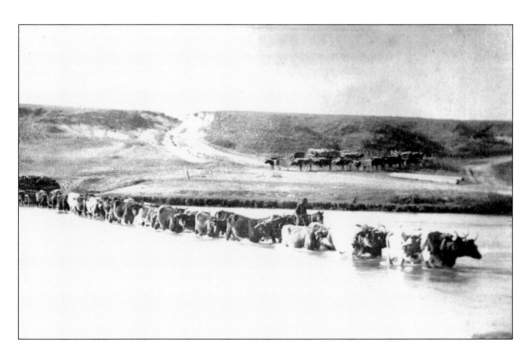

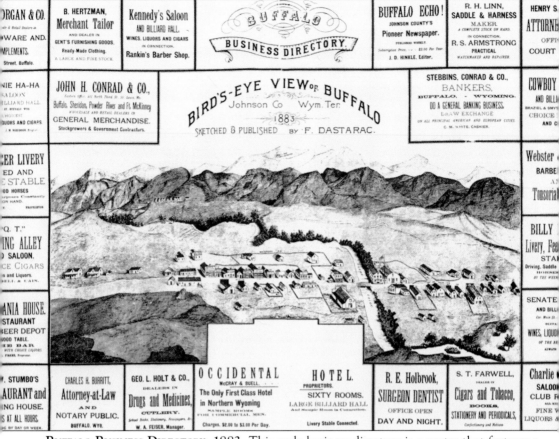

BUFFALO BUSINESS DIRECTORY, 1883. This early business directory is a poster that features a drawing of the Buffalo community with Clear Creek flowing though town and the Big Horn Mountains in the background. The listing of businesses and professional services is impressive, and they more than balance the six saloon advertisements. This amount of early development is due to the Fort McKinney garrison and the number of ranches and farms that have been established in the surrounding region. (OHM.)

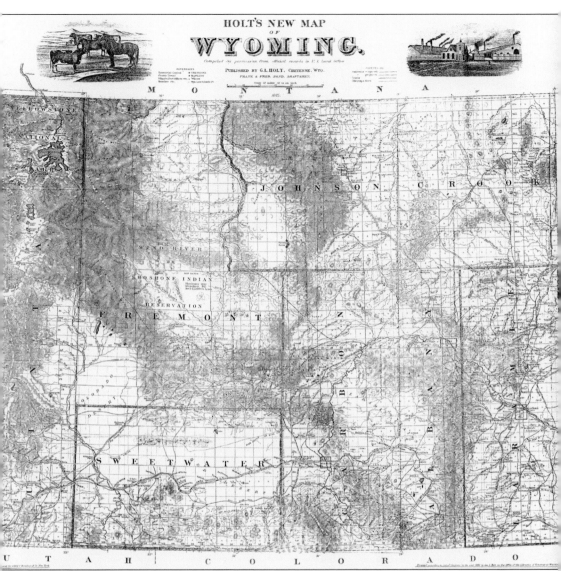

G. L. Holt's Wyoming Map, 1885. This map of Wyoming, at a scale of 1 inch equal to 12 miles (approximately 1:750,000), was one of the early, commercially published maps of the Wyoming Territory. It shows considerable detail: townships and ranges, rivers and streams, cities and towns, trails, roads and railroads, ranches, and forts. The size was 32-by-28 inches, and its excellent accuracy was based on use of U.S. Land Office records. Wyoming history students have found the map to be a "most helpful cartographic tool." (OHM.)

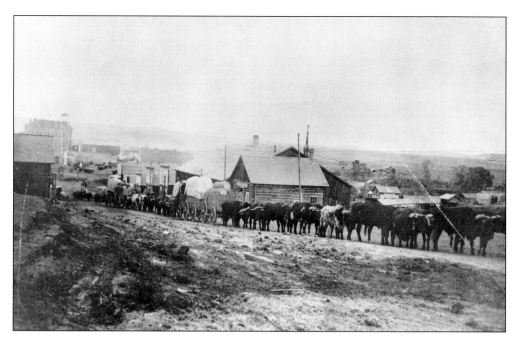

BUFFALO MAIN STREET, MID-1880S. The photograph above shows several freight teams on Buffalo's South Main Street heading upslope from Clear Creek. The closest one, with seven yoke, is attributed to freighter Tom Haines. The county courthouse, with its cupola, is shown in the center background near the left edge. The wagons are headed south, indicating they are leaving Buffalo and that their cargoes are probably destined for the Casper or Cheyenne areas. Another series of freight wagons on Buffalo's Main Street is shown on the undated photograph below. Rather than oxen, these wagons are drawn by teams of horses and perhaps mules also. The street is not surfaced and the number of buildings few; Buffalo is clearly a work in progress. The wagons are headed into Buffalo with cargoes from the Union Pacific railheads at Medicine Bow and Rock Creek, some 200 miles distant, and destined for Buffalo and/or Fort McKinney. (Above, BBN; below, JGMM.)

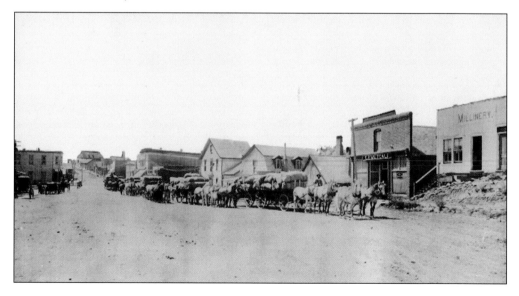

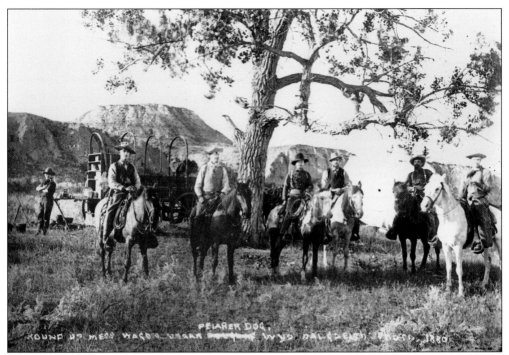

CATTLE ROUNDUP, 1880. Six mounted cowboys are depicted here in front of a roundup's chuck wagon with the cook standing nearby. The weather is obviously good as the chuck wagon's canvas cover is not in place. The handwritten caption gives the location as near Prairie Dog Creek, with "prairie" being badly misspelled—even after two attempts. That stream is located north of Buffalo. (JGMM.)

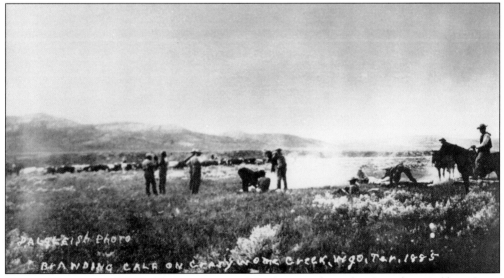

CATTLE BRANDING, 1885. The caption on this photograph reads, "Branding Calf on Crazy Woman Creek, Wyo. Ter., 1885." That stream is the first Powder River tributary south of Buffalo's Clear Creek. With the virtual absence of prominent landmarks on the prairie, streams became the principal identifier of general location, as was done here. Specific sites were designated by reference to stream-trail intersections or stream-ranch locations. (JGMM.)

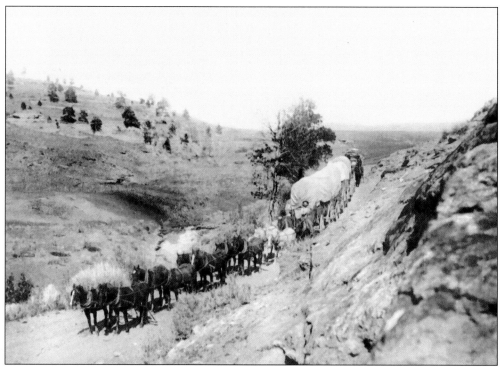

FREIGHTING, MID-1880S. The people in Buffalo and soldiers at Fort McKinney needed goods and luxuries that could not be produced locally. All such items had to be freighted in from the nearest Union Pacific railheads to the south. The transit time for the freighters in good weather was generally 9 to 10 days, but there was one instance when the trip took two months because of early winter weather. Freight outfits, or caravans, varied widely in size and number of workers—the largest consisted of about 25 wagons with a total crew of some 35 men. Each freight wagon hauled up to 3 tons and was pulled by 7 to 10 yoke of oxen; mules and horses also came into use. A 12-horse rig (in 1883, pictured above) and a 20-bull team (in 1885, shown below) are headed to Buffalo. (Both, JGMM.)

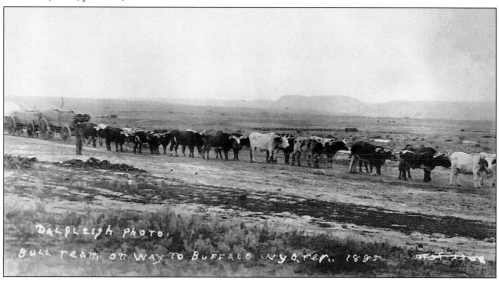

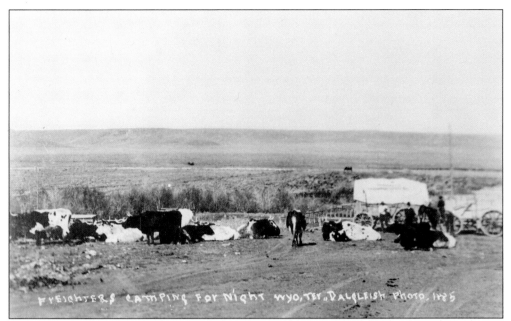

FREIGHTERS' CAMP, MID-1880s. These two photographs show a bull freighting outfit settling in after a long day's work. Both are dated 1885. In the photograph above, the oxen are starting to lie down and the wagons and men are seen behind them. The view is to the east over the relatively flat-lying prairie. On the back of the photograph, the location is identified as High School Hill in Buffalo, which is at the intersection of present-day Burritt and Parmelee Streets. The photograph below gives a close-up of the teamsters, their wagons, and camp. The large pots on the ground indicate a meal is in progress or just finished. (Above, JGMM; below, BBN.)

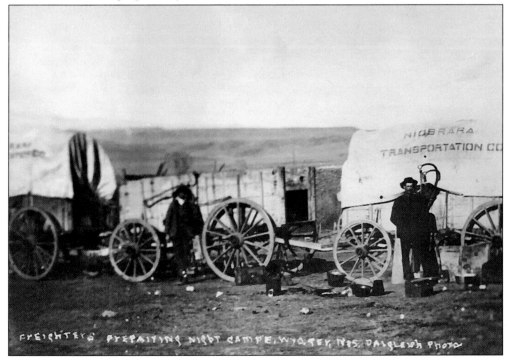

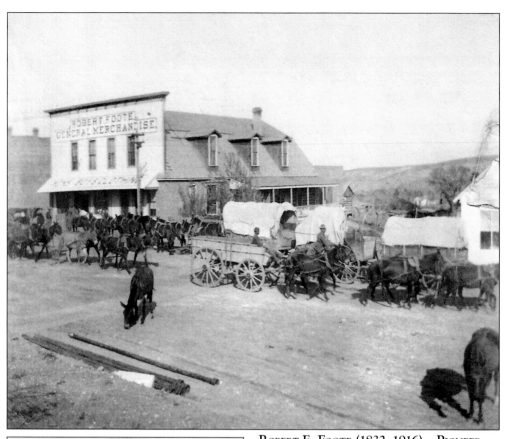

ROBERT E. FOOTE (1832–1916)—PIONEER MERCHANT. Robert Foote was born in Scotland, immigrated to America, and reached Wyoming in 1856. He worked as Wyoming's pre-territorial sheriff, a military post trader, a farmer, and a freighter. There is a story about his being robbed while freighting by a band of Native Americans and then abandoned on the prairie. He later saw their leader at Fort Laramie, whereupon Foote drew his dragoon pistol and shot the man dead. When he explained the reason for his actions to the military authorities, the matter was dismissed. Arriving in Buffalo in 1882, he opened a general merchandise store in a large, two-story log structure with a false front (pictured above). Foote was always neatly dressed and sported a long beard (shown at left). During the 1892 Cattle War, he threw open his store to supply Buffalo residents for their fight against the invading cattlemen barricaded at the TA Ranch south of town. (Above, BBN; left, JCL.)

CHARLES H. BURRITT (1854–1927)—PIONEER LAWYER. Burritt was born in Vermont and was educated at Brown University. He came to Buffalo in 1883 and began a law practice. His dress—black frock coat, vest, and striped trousers—was distinctive in that frontier community. Burritt became the attorney for several of Johnson County's large ranchers and was active in politics: he was Buffalo's second mayor and was a member of the 1889 State Constitutional Convention. He was the prosecuting attorney at a local murder trial that led to Buffalo's only hanging, in 1886. (OHM.)

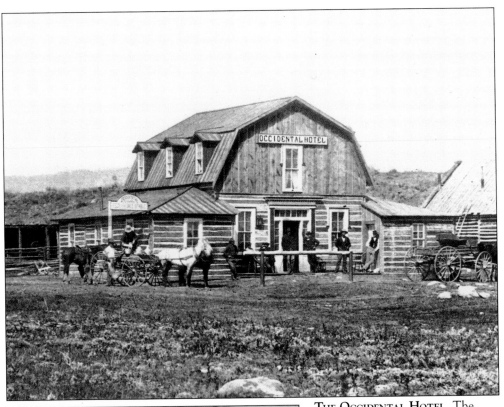

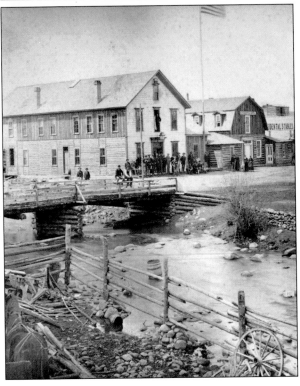

THE OCCIDENTAL HOTEL. The Occidental Hotel and Buffalo started together and grew up together. The pioneer hotel's log structure was completed in 1880 (pictured above) and quickly became the center of activity for newcomers, public meetings, and social gatherings in the new community on Clear Creek. At various times during the ensuing years, the hotel served as hospital, bank, polling place, courthouse, Western Union office, and stagecoach stop. The early hotel registers showed such names as William F. Cody, Teddy Roosevelt, Gen. Phil Sheridan, Gen. George Crook, and Calamity Jane. The structure was added on to several times (shown at left) and then, between 1903 and 1910, completely replaced by a brick structure that continues operation today as a historic hotel and museum. (Both, OHM.)

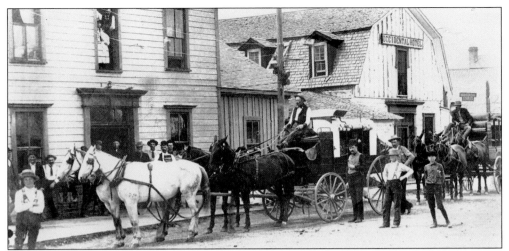

OCCIDENTAL STAGECOACH STOP. Two stagecoaches are shown stopped in front of the Occidental Hotel, and there is a gathering of Buffalo residents to pose for the photographer. This was an auspicious occasion of some sort, but, unfortunately, no information accompanies this historic photograph. The time is the mid- to late 1880s. (OHM.)

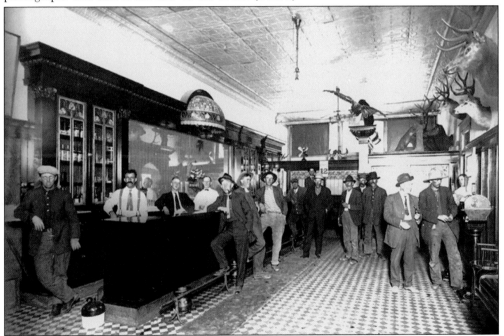

OCCIDENTAL SALOON. This 1908 photograph shows the elegant new saloon that replaced the original, rough barroom in the hotel. There is a 25-foot-long bar, an imposing back bar with stained-glass fixtures, an embossed metal ceiling, and a tile pattern floor. There were a number of fights and shoot-outs over the years in this saloon, and bullet holes in the ceiling can still be seen (they were deliberately left in during its restoration). One story concerns two 1892 Cattle War antagonists, Frank Canton and Will Foster, when they met years later at the Occidental bar. There was still bad blood between them, and an argument quickly developed. Both men drew their pistols, and Foster was the quicker. Instead of shooting Canton, Foster hit him with his gun. A pistol slugfest followed with Foster the clear victor, but Canton survived and then left the area. (OHM.)

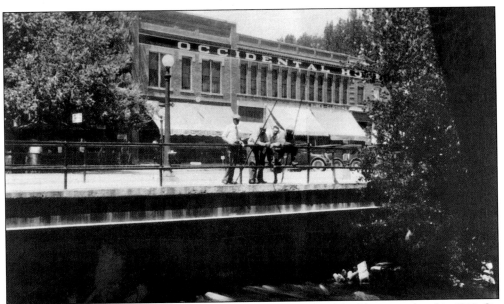

OCCIDENTAL HOTEL, 1927. The Occidental shown here is the brick building completed in 1910. On the first floor were the lobby, dining room, kitchen, saloon, and barbershop. Guest rooms occupied the second floor. The bridge over Clear Creek, complete with fishermen, is in the foreground. The hotel has now occupied the same site for well over a century. During the cattle boom years in the late 19th century, it was common for the large ranches to rent Occidental rooms on an annual basis for the routine use of their family and guests when they were in Buffalo. (OHM.)

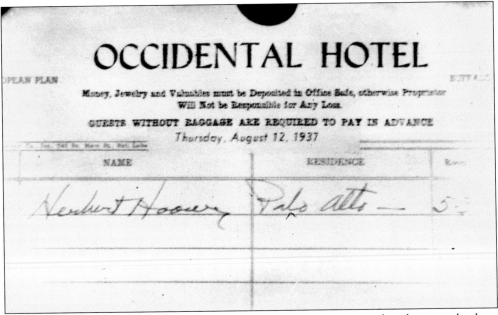

OCCIDENTAL GUEST HERBERT HOOVER. In addition to the famous guests listed previously, there was an early visit by President Roosevelt and a later one by Pres. Herbert Hoover, who registered on August 12, 1937. Also, Ernest Hemingway and Owen Wister, author the 1902 Western classic novel *The Virginian*, were Occidental guests. Many historians believe the shoot-out climax of Wister's book, when "the Virginian got his man," was scripted in front of the Occidental. (OHM.)

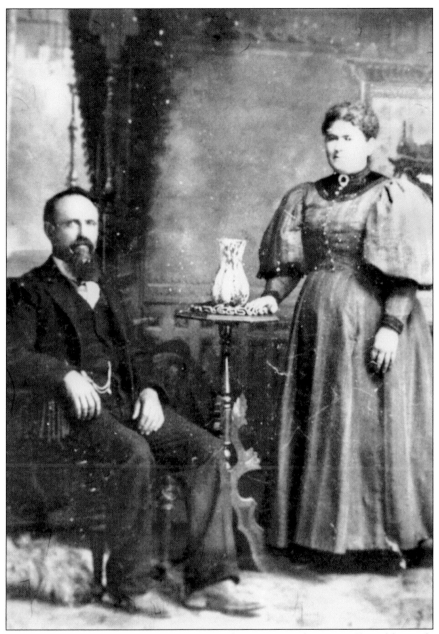

THE HARTS, PIONEER ENTREPRENEURS. Maj. Verling K. Hart (1838–1883) and his wife, Juliet Watson Hart (born 1848), were entrepreneurs in the full sense of the word. When the major assumed command of Fort McKinney late in 1878, he promptly filed a Desert Land Entry claim for the land adjoining the post's eastern boundary. Following his unexpected death five years later, that patent was transferred to his widow. Juliet Hart now "owned" Buffalo, and its several hundred residents had to buy the property they were occupying from her. Major Hart had a pattern of engaging in land speculations in the vicinity of his posts. Earlier, when at Fort Laramie, he had located a rich copper claim nearby that developed into a namesake town, Hartville. Later, in 1907, Juliet Hart developed a mineral patent of her own in adjacent Platte County. Over time, she effectively managed all of her land holdings and was quite successful. (JCL.)

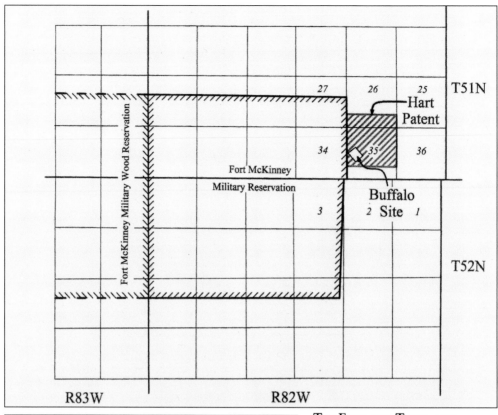

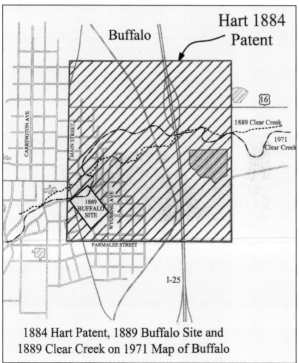

1884 Hart Patent, 1889 Buffalo Site and
1889 Clear Creek on 1971 Map of Buffalo

THE FORT, THE TOWN, AND THE HART PATENT. The spatial relationships between Fort McKinney, the Hart Patent, and the town of Buffalo are shown by these maps. The above map presents the legal land description of the townships, ranges, and sections involved. Each section (small italic numbers) is one square mile, and the Hart patent was that size. The map at left depicts a superposition of (1) the 1884 Hart Patent area and (2) the 1889 Buffalo site (location, not full size) onto a 1971 street map of Buffalo. Also shown are the 1889 and 1971 courses of Clear Creek. There has been some expectable migration in the stream bed over time, but it is clear the Hart Patent was centered on that stream. (Both, author's collection; graphics by Bighorn Technical Design, Buffalo, Wyoming.)

Two

EARLY TOWN AND COUNTY GROWTH
1886 TO 1891

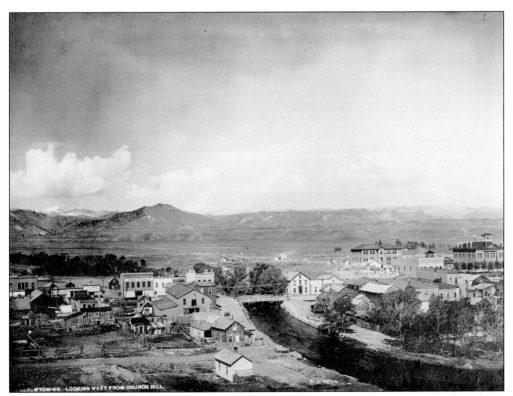

BUFFALO, LATE 1880s. This view of Buffalo looks to the west and shows Clear Creek and its Main Street Bridge in the foreground with the Big Horns on the horizon. This summer scene depicts the Occidental Hotel to the immediate right of the bridge, while the county courthouse with its distinctive cupola is shown on the photograph's right edge. The large building behind it and to the left is the schoolhouse. (OHM.)

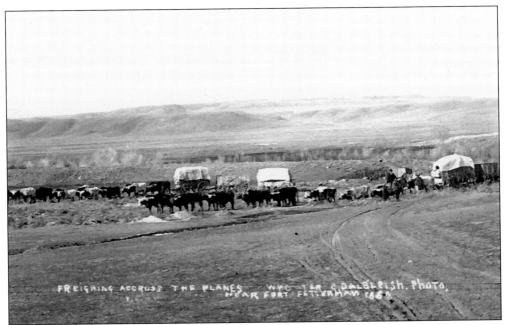

FREIGHTING, LATE 1880s. Buffalo and Fort McKinney depended on freighting for a wide range of essential supplies. Both oxen and horse teams provided for the transport of those materials (pictured above) as well as taking local livestock products to the railheads. By 1886, there were more than 6,000 sheep in Johnson County, and their wool was taken to market by horse-drawn wagons (shown below). The peak of an early cattle boom in Wyoming was 1884, when there were 175,000 head in the county. Due to market changes and weather losses, that number decreased to 150,000 in 1886. Cattle were, of course, trailed to the railroad stockyards for shipment and sale. (Above, JGMM; below, BBN.)

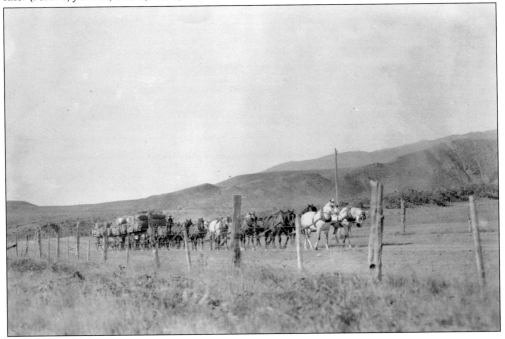

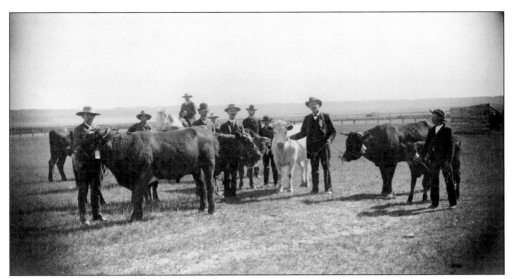

FIRST COUNTY FAIR, 1887. Western county fairs are an annual gathering of residents to enjoy a parade and rodeo, display agricultural products and other goods, and exhibit livestock. Johnson County held its first county fair at Buffalo in 1887. The illustrations are from that event and portray cattle judging (pictured above) and agricultural produce competitions (shown below). As the county seat, Buffalo has continued to hold the fairs. Its rodeo includes bareback and saddle bronc riding, bull riding, calf roping, bulldogging, and ladies barrel racing. There are multiple livestock events, such as cattle, sheep, and swine judging, as well as stock dog trials and competitions in agriculture, cooking, and needlework events. (Both, JGMM.)

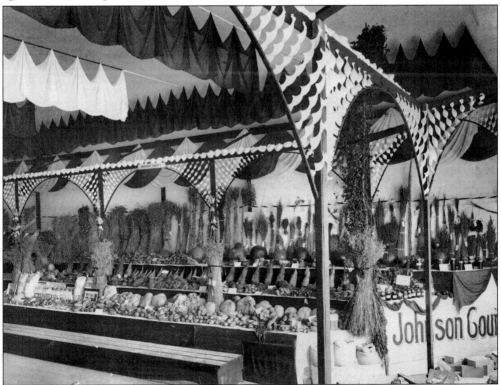

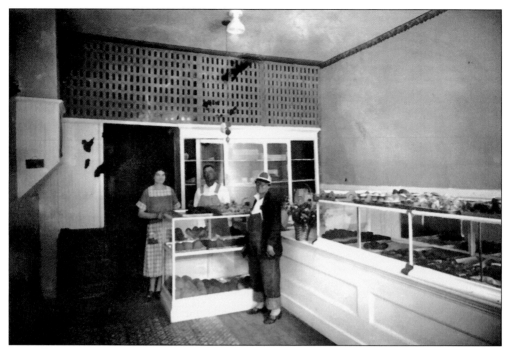

BUFFALO GROCERY STORES. The early food stores in Buffalo were about as small and simple as today's supermarkets are large and complex. As the photographs here portray, their stocks were minimal, and the stores themselves had only plain, undecorated walls. The photograph above was labeled "Table Supply Grocery" and the one below as "Buffalo Bakery." Neither the individuals shown nor the dates the pictures were taken were identified. (Both, JGMM.)

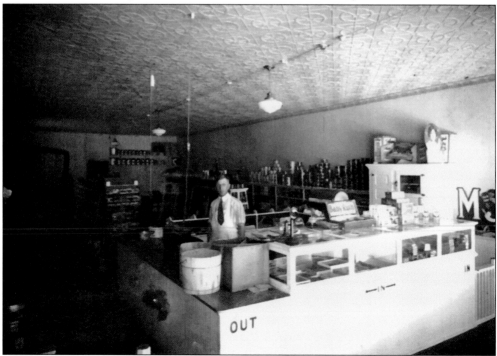

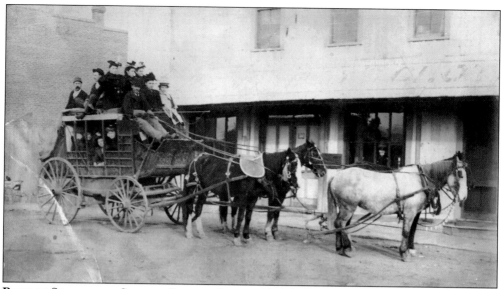

BUFFALO STAGECOACH SERVICE. Stagecoaches provided the first public transportation to and from Buffalo. The earliest of those routes ran from the Rock Creek railroad station in southern Wyoming through Buffalo and then northward to Junction City, Montana. In addition to passengers, mail was carried to Fort McKinney and to Fort Custer in Montana. Buffalo was one of the principal stage stations along that route. An 1886 travel account tells of leaving Rock Creek and traveling for the first day in a full-size Concord Stagecoach such as those used by Wells Fargo and the Overland Stage. The remainder of the 300-mile, three-day trip to Buffalo was then finished in a smaller stagecoach called a Jurkey. These photographs show views of Jurkey stagecoaches in Buffalo. Why the properly clad ladies and gentlemen are stacked so tightly in the above view is unknown; perhaps it is for a photo op. The railroad did not arrive in Buffalo until 1918, and thus stagecoach service was maintained longer than in other frontier communities with earlier rail access. (Both, JGMM.)

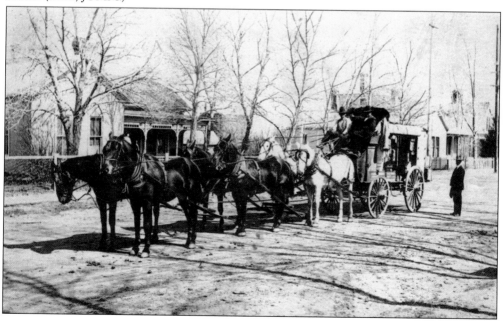

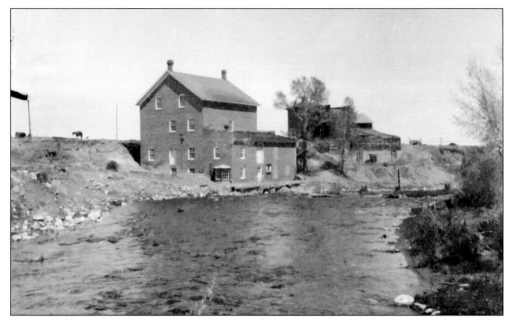

BUFFALO'S FIRST INDUSTRIES. Clear Creek provided the water and hydraulic power for Buffalo's earliest industrial plants. The first to be developed was a brewery by Bavarian immigrant John A. Fischer in 1882. Its dependence on the drinking appetites of the soldiers at Fort McKinney was perhaps stronger than expected. It closed in 1895, just one year after the post was decommissioned. A flour mill, adjacent to the Fischer Brewery, was opened in 1886 by George T. Beck and partners. Its flour, milled from local wheat, was of high enough quality to win awards at the St. Louis and Portland World Fairs. A dynamo was added to the mill plant, and in 1888, Buffalo began to enjoy electric lighting. The flour mill (left) and brewery are pictured at their Clear Creek site in the above image. The addition of the electric plant buildings to the mill is documented in the photograph below. (Above, JGMM; below, BBN.)

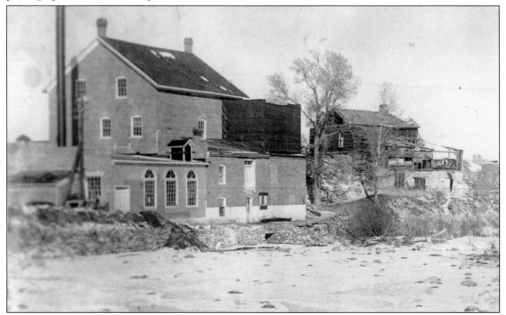

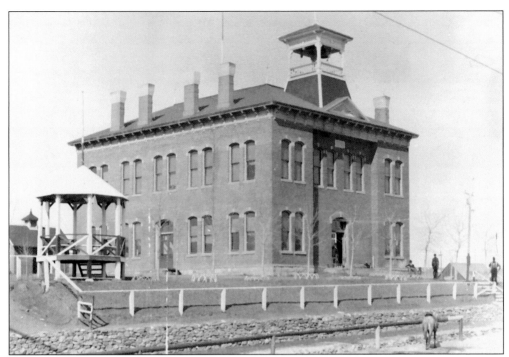

BUFFALO'S COURTHOUSE AND SCHOOL BUILDING. As Johnson County's seat, Buffalo built a courthouse in 1884. An 1889 picture of that structure is shown above. Note the long hitching rail along Main Street with one horse tethered. The courthouse is located at a high point on North Main Street, making its white cupola easy to identify in Buffalo photographs taken during the following years. Buffalo's original school building, seen below, was completed in 1886. In 1892, high school classes were begun on the second floor, making it one of the earliest high schools in the state. Wilson McBride was both principal and faculty at the time to the 13 secondary-level students enrolled in four subjects. (Above, JGMM; below, BBN.)

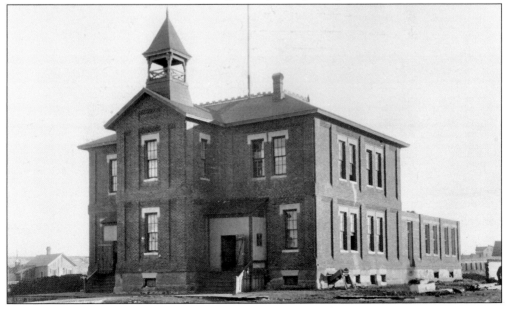

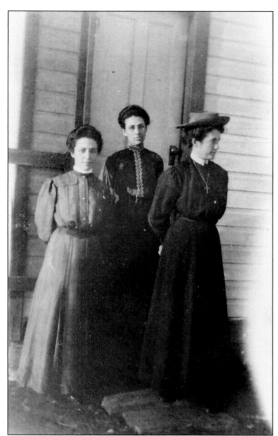

EARLY SCHOOL MARMS AND THEIR PUPILS. The three Johnson County schoolteachers shown at left certainly appear to be stern, no-nonsense individuals. It was definitely reading, writing, and arithmetic—or else. The students depicted in the photograph below have expressions that range from serious to pleasant—understandable if their teacher was similar to those shown at left. Small, rural schoolhouses with only several students were common in the county's early decades. Both photographs were undated, but the one of students may be the earlier, as they are in a log schoolhouse while the teachers are in front of a finished lumber building. (Both, JCL.)

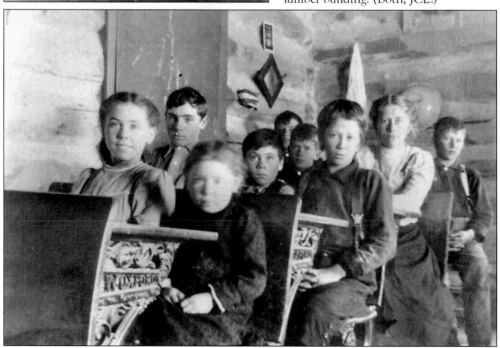

PAP MYERS'S HOTEL AND BAND.
George F. "Pap" Myers (1849–1926) was a Bavarian native who came to Buffalo in 1882. He opened the Myers Hotel on North Main Street across from the present-day courthouse. The hotel is shown in the photograph above with Myers standing at the doorway; the others are unidentified. Myers was a musician of exceptional ability and was involved with every Buffalo Municipal Band, from the first in 1882 until his death—they were all referred to as "Pap Myers' Band." Those bands gave a concert on the courthouse lawn each Thursday. A Fourth of July parade, marching past the Occidental Hotel, is depicted at right. At Myers's request, the Municipal Band played at his funeral church service and at the cemetery burial. (Both, JGMM.)

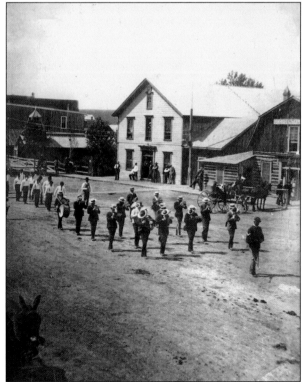

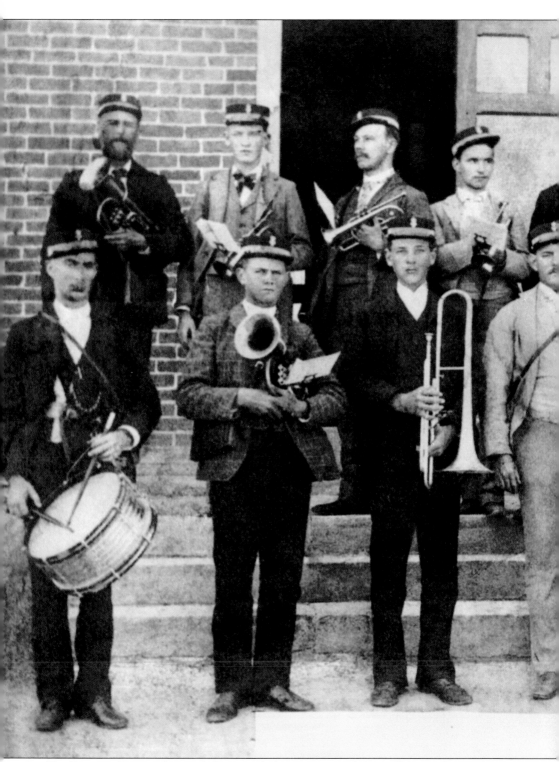

THE BUFFALO BAND. This 1885 photograph shows Myers and the Buffalo Band. From left to right are (first row) Rob Watkins, Frenchy, Fred Newell, Hugh Smith, J. C. Van Dyke, Judge Henry S.

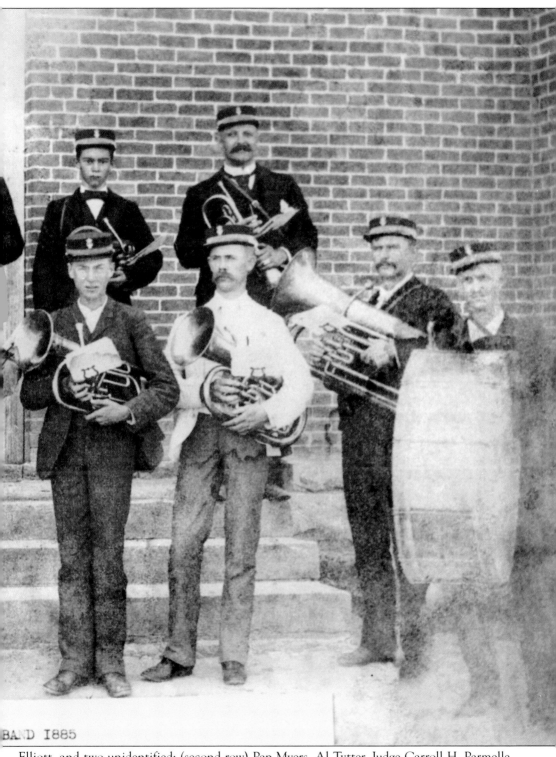

BAND 1885

Elliott, and two unidentified; (second row) Pap Myers, Al Tytter, Judge Carroll H. Parmelle, Sanders Orr, Gustov Moeller, Art Herric, and Alva Hoppkins. (JGMM.)

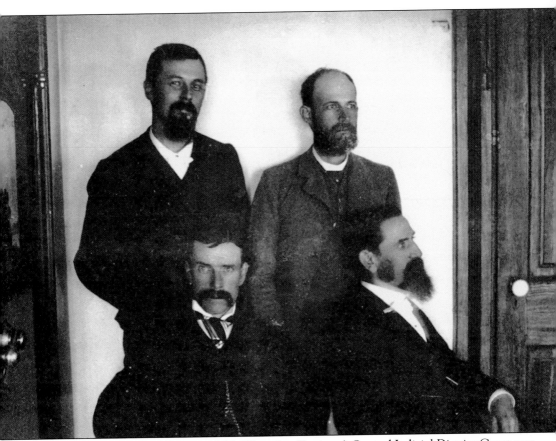

WYOMING TERRITORIAL COURT, 1888. Wyoming Territory's Second Judicial District Court was located in Buffalo with Judge Micah C. Saufley (first row, right) presiding. An imposing man, he was over 6 feet tall with a large mustache and heavy goatee. A Kentucky native, he served as a Confederate army officer before coming to Wyoming. Known as a competent and fair judge, he was said to have carried a Colt .45 under his black frock coat and a large knife in his boot, and he knew how to use them. Clerk of the court was Charles T. Gale (first row, left), about whom little is known. The court's deputy clerk was T. P. Hill (second row, right), who was also a practicing attorney. Hill was a Kentucky native and friend of Judge Saufley, who had advised him to come to Buffalo because it was "the most promising town north of the Union Pacific Railroad." Attorney Charles Burritt (second row, left) has been discussed previously. (JGMM.)

JOHNSON COUNTY HOMESTEADING. The markets offered by Fort McKinney and Buffalo were a strong inducement to settle on the surrounding Johnson County prairie. The first Homestead Act was signed into law by President Lincoln in 1862. There followed a number of subsequent such laws designed primarily to accommodate the western, semiarid climate conditions. In particular, the 1877 Desert Land Act that granted 1 square mile, 640 acres, if the land was irrigated, was particularly appropriate for the Northern High Plains. Farmers, ranchers, and land speculators took advantage of that law, as was noted previously for Maj. Verling Hart at Fort McKinney. Shown are homestead houses on Shell Creek north of Buffalo (pictured above) and on Powder River south of town (shown below). (Both, JGMM.)

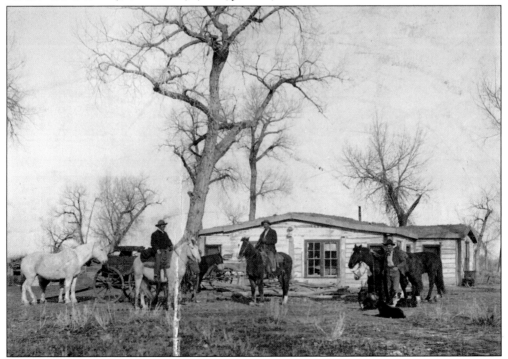

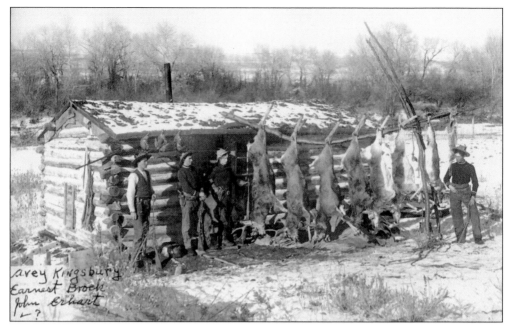

Harvey Kingsbury
Earnest Broch
John Erhart
L~?

HUNTING AND FISHING. Many, if not most, Johnson County residents have enjoyed hunting and fishing from frontier times to the present. The mountains-plains setting provides excellent wildlife habitat, and the scenery is unexcelled. Not only are those sports healthy outdoor recreation, but they have the added advantage of providing meat for the table. That was, of course, particularly important for early homesteads that were getting started with minimal resources. As these photographs document, the big game hunting and trout fishing were excellent. Also, given the wildlife and human population numbers of the time, game and fish limits were not necessary. (Both, JGMM.)

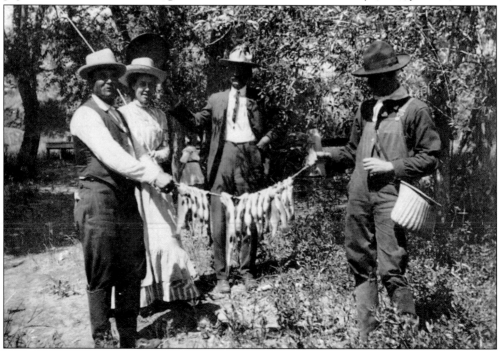

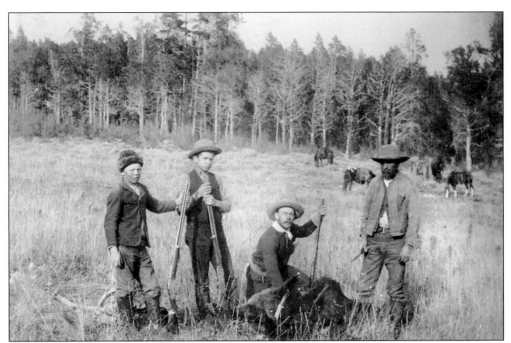

BEAR HUNTERS. Not all of the big game hunting in the Big Horn area was limited to antlered critters such as deer, elk, and pronghorn. In the photograph above, four hunters, two adults and two youngsters, are shown with a black bear they have bagged. The kneeling hunter, presumably the one who shot the bear, could be a soldier (possibly from Fort McKinney) given his dark clothing, cartridge belt, and light bandana. It is interesting that the long barrels on the boy's rifles make them the biggest firearms shown. It is also interesting that the horses shown are contentedly grazing not far from the downed bruin, as his scent is usually disturbing to stock animals. In the photograph below are two hunters and a large bear identified as a grizzly in the photograph's caption. (Both, JGMM.)

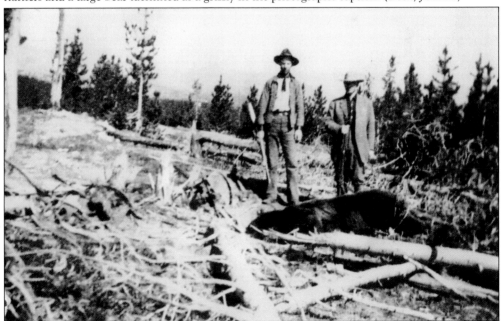

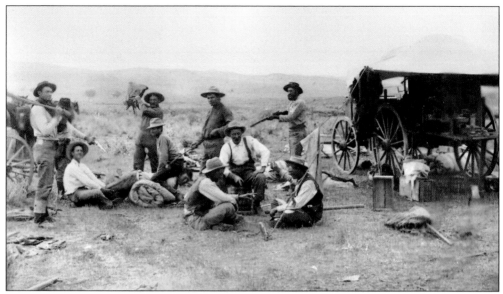

ROUNDUP CHUCK WAGON. The chuck wagon, a mobile kitchen on a sturdy four-wheeled wagon with bows across the top to hold a waterproof covering, was an essential component of every cattle drive. The photographs here present two images of early chuck wagons on the Wyoming prairie. The above image depicts cowboys clowning at the chuck wagon—pointing guns at each other and playing a card or dice game on a blanket. The cowboy at the rear is holding something up that is not discernible, perhaps for the best. The photograph below has cowboys using their ropes and horses to help the chuck wagon up a steep grade. It was obviously necessary for the chuck wagon to follow the cattle herd as it was more than just a place to eat meals. It was the operational headquarters and social center for the entire period of the cattle drive. (Both, JGMM.)

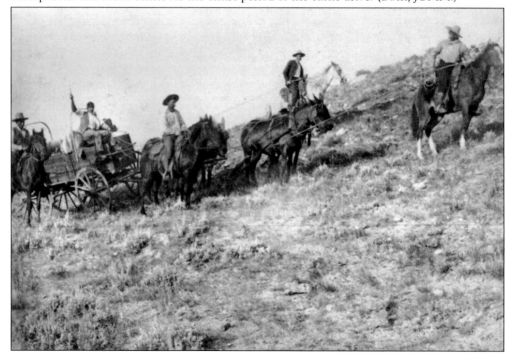

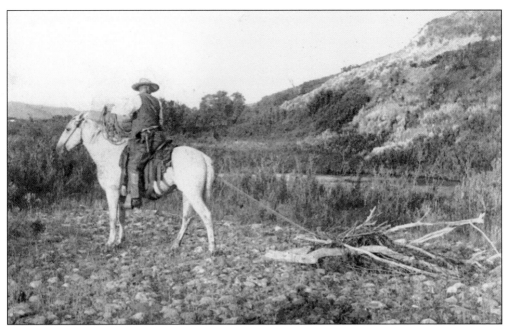

COWBOY CHORES. It has been said that a cowboy will attempt almost anything—as long as it is on horseback. The photograph above seems to bear that out as it shows a cowboy and his horse dragging a load of firewood for the cook's use at the chuck wagon. The image below presents a more typical cowboy chore—branding. The location is southern Johnson County, and two cowboys are branding a large steer. In the days of open-range grazing, it was not uncommon for a few calves to escape their first roundup or two and grow to full size unbranded. That may be the case here. The branding shown is on the ranch of Henry Winter Davis, known as "Hard Winter" Davis. He would later be involved in the 1892 Cattle War. (Both, JGMM.)

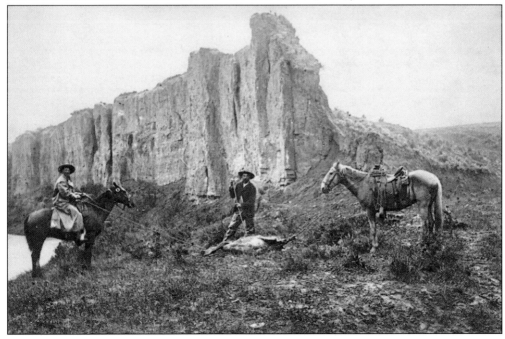

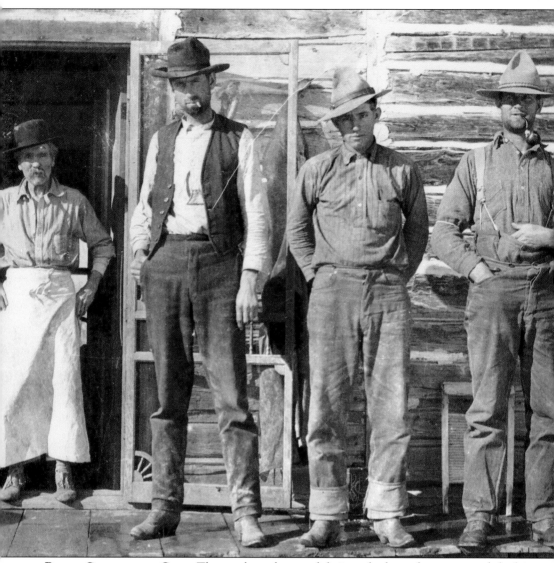

RANCH COWBOYS AND COOK. The ranch cowboys and their cook, shown here, are rough-looking characters. Their names along with the location and date are unknown. An estimate of the year based primarily on their clothing would be around 1900. The *Buffalo Bulletin* printed this group photograph in 2001 asking for information, but there was no response. (BBN.)

KAYCEE AND MAYOWORTH. Buffalo was, of course, not the only community developing in early Johnson County. Kaycee, in the southern part of the county, was named for the KC brand owned by rancher John Nolan. Postal regulations would not allow just letters for the name of a post office, so the brand was spelled out. The community was started in 1896 and incorporated in 1906. The photograph above shows the Kaycee Town Hall building in 1897. Kaycee's present-day population is approximately 300, and it remains the only incorporated town in the county besides Buffalo. The image below is of Mayoworth, another ranching community, in 1890. Located 15 miles northwest of Kaycee, it was named by the first postmaster, Charlotte L. Jones, for her daughter May and her husband, William Worthington. The names for frontier Wyoming towns became official only after a post office permit was obtained from the federal government. (Both, JGMM.)

YOUNG RANCH HANDS. With horses as the only method of transportation short of walking, youngsters needed to learn how to stay astride a horse at an early age. They were usually taught to ride almost before they learned to walk, which would seem to be the case here for the rider in front. (BBN.)

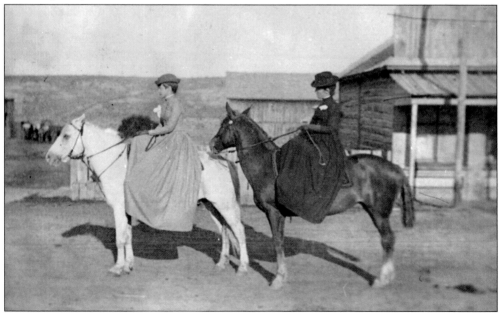

LADY EQUESTRIENNES. The caption written on this photograph reads, "A common sight in Buffalo in the late 1880s was one such as this, when the young matrons traveled horseback to go visiting or just for a brisk canter. Shown here are Mrs. George Munkres and Mrs. J. H. Lott. The building in the [center] background is the old Munkres and Mather barn and feed store." (JCL.)

Three

CATTLE WAR
AND INVASION
1892

EARLY EVENT, 1891. The Johnson County Cattle War was a protracted conflict that included five killings and two lynchings, which occurred both before and after the April 1892 invasion by the Wyoming Stock Growers Association (WSGA) and their hired Texan gunmen. Their intent was to kill suspected rustlers in Johnson County, particularly at Buffalo. This photograph relates to one of the preceding events. The Hall Cabin was the site of a predawn attack by a group of WSGA detectives led by Frank Canton on two cowboys, Nate Champion and Ross Gilbertson, who they considered to be rustlers. Gunfire was exchanged, and one of the attackers was killed. (JGMM.)

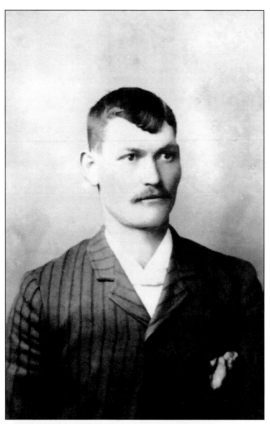

NATE CHAMPION (1857–1892), COWBOY AND RANCHER. Champion, a local leader of Johnson County's small ranchers, was one of the first victims of the invaders. In the predawn hours of April 9, 1892, a force of 50 invading large cattle ranchers and hired gunmen surrounded Nate and his companion, Nick Ray (Rae), at the KC Ranch house. The invaders killed Ray leaving the cabin and then fired on Champion inside. He made a heroic stand against overwhelming odds for several hours, providing time for Buffalo to be warned and prepare to defend itself. The attackers finally set fire to the cabin and killed Champion when he ran out. The photograph at left of Champion is reputed to be the only picture of him confirmed as authentic. In the 1880s photograph below, at a roundup chuck wagon, he is supposedly the second from the left. The others are unidentified. (At left, JGMM; below, JCL.)

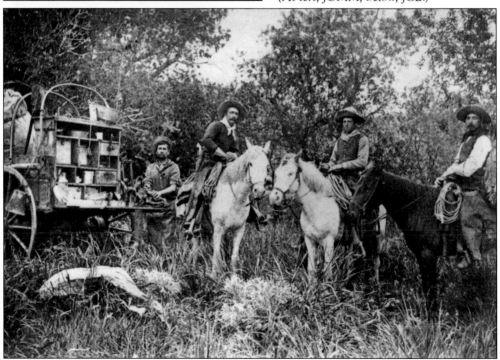

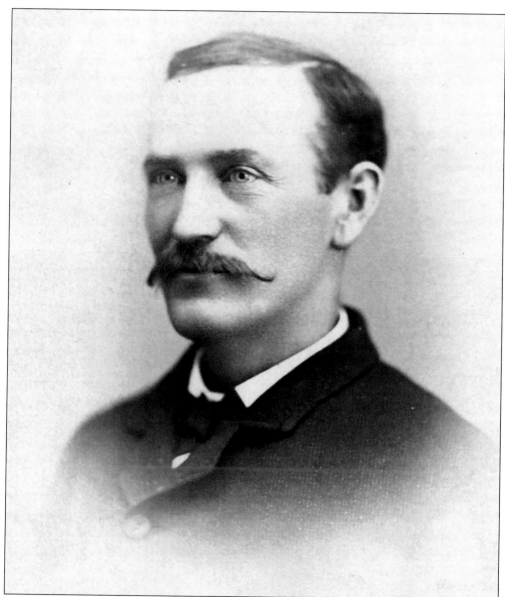

FRANK M. CANTON (1849–1927), INVASION LEADER. Canton was a Johnson County sheriff (1882–1886) and was then hired to lead stock detectives for the WSGA. He was suspected of being their assassin, especially in the December 1, 1891, killing of rancher John A. Tisdale. Then, in 1892, Canton was with the Wyoming Stock Growers Association invasion force and present at the killings of Champion and Ray. After that conflict, Canton returned to law enforcement in Oklahoma as a deputy marshal. In 1907, he became adjutant general for that state's National Guard, a position he held until he retired in 1916. (JCL.)

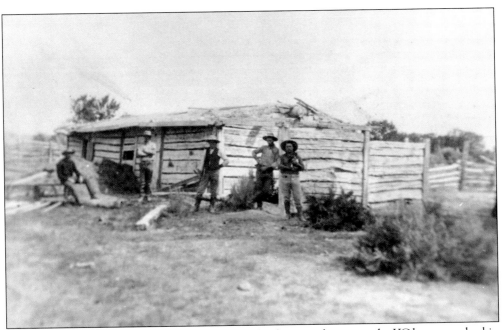

KC RANCH BARN—BATTLE STATION. This small log barn is adjacent to the KC homestead cabin that Nate Champion defended against his WSGA attackers. Some of them used this structure as a protected site for shooting at Champion. Both structures were just south of the Middle Fork of Powder River and in the immediate locale of the present-day community of Kaycee. (BBN.)

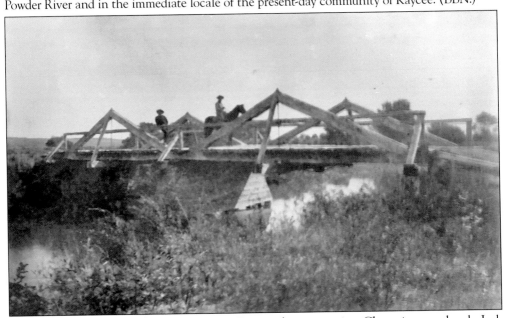

BRIDGE AT KAYCEE—INVADERS DISCOVERED. During the siege against Champion, two locals, Jack Flagg on horseback and his 17-year-old stepson Alonzo Taylor driving a wagon and team of horses, approached the KC ranch area in the early afternoon. The invaders called for them to stop and then opened fire when they didn't, but neither traveler was hit. The gunfire noise stampeded the team of horses across the bridge over Powder River shown above. Flagg and Taylor then escaped and spread the alarm to Buffalo. (JGMM.)

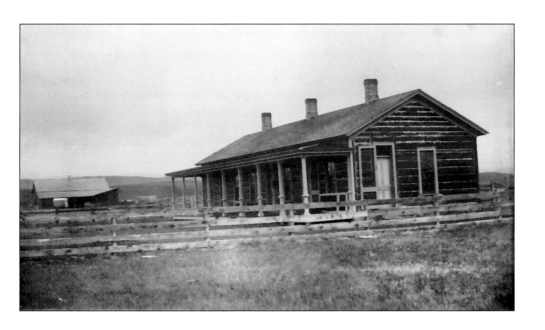

TA Ranch, the Final Battle Site. After killing Champion and Ray, the WSGA invaders traveled north and stopped for the night at the friendly TA Ranch, some 13 miles south of Buffalo. Following an early departure for Buffalo the next morning, their outriders returned to warn that a large posse of armed men from Buffalo was headed their way. The group of 50 then returned to the TA and barricaded themselves in preparation for a siege. The ranch house was strongly made of heavy logs and a good site to defend. Two early views are shown here. (Above, JGMM; below, JCL.)

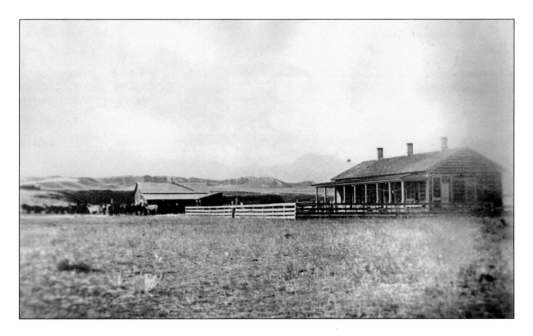

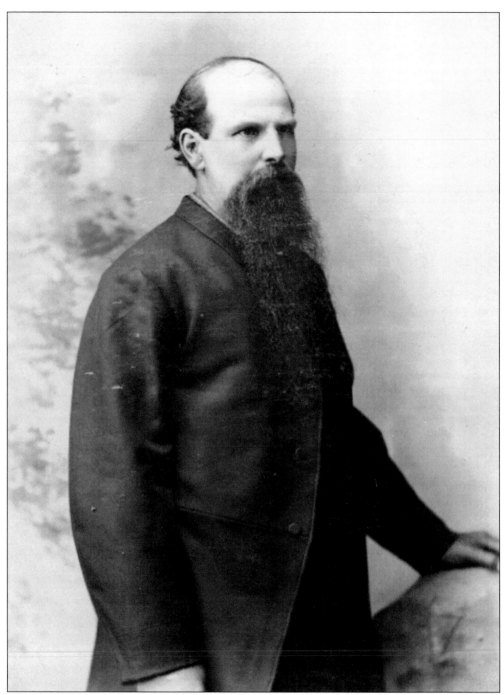

ARAPAHOE BROWN, POSSE LEADER. Andrew "Arapahoe" Brown was one of early Johnson County's more colorful, if not notorious, characters. He had been in the Union army during the Civil War, after which he came to Wyoming and lived with the Arapaho tribe for a number of years as a trader. When the invaders' approach became known in Buffalo, Sheriff Red Angus was investigating at the KC cabin, and Brown took charge of forming the posse and leading it on its mission south of town. (JGMM.)

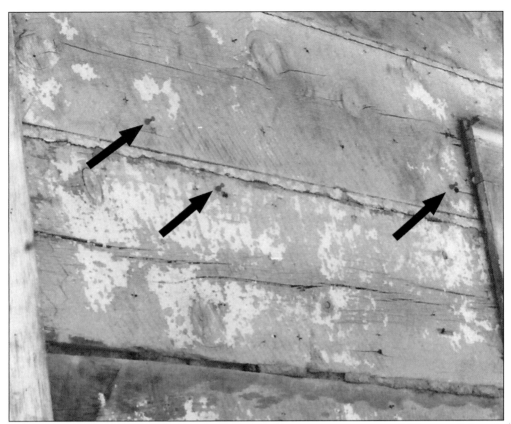

TA Ranch Bullet Holes. The photograph above shows a pre-restoration 1992 view of the side of the TA Ranch house. Three identifiable bullet holes are marked with map tack pins. The TA barn was also used for defense by the invaders. Large holes were drilled through the second-floor barn wall to provide firing ports. At least three can be seen, as dark dots on the same level below the top window, in the photograph below. (Above, JCL; below, BBN.)

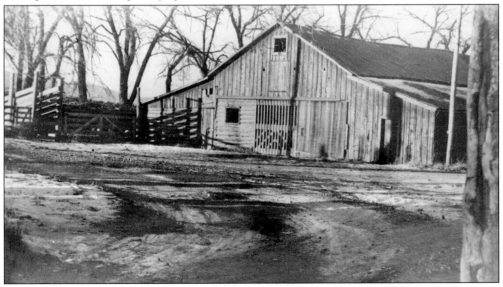

CATTLEMEN'S FORT AT THE TA RANCH. This makeshift fort was constructed of heavy, thick, wooden planks by the invaders on a knoll to the west of the TA house and barn. Maj. Frank Walcott, an invasion leader, had directed the building of the small fort, and it came to be called Fort Walcott. From April 10 to 13, 1892, the Buffalo posse held siege on the invaders at the TA Ranch. The conflict was ended by the arrival of Fort McKinney troops, who arrested the invaders. (JGMM.)

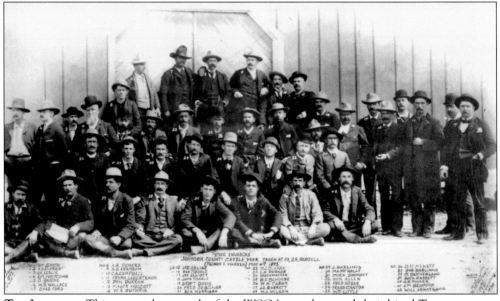

THE INVADERS. This group photograph of the WSGA members and their hired Texan gunmen was taken on May 4, 1892, while they were "incarcerated" at Fort D. A. Russell in Cheyenne. Forty-three men in suits, ties, and a variety of hats are pictured. This is a famous photograph and depicts men who do not appear to be prisoners. The cattlemen's legal teams would eventually free the group of all criminal charges. (University of Wyoming, American Heritage Center.)

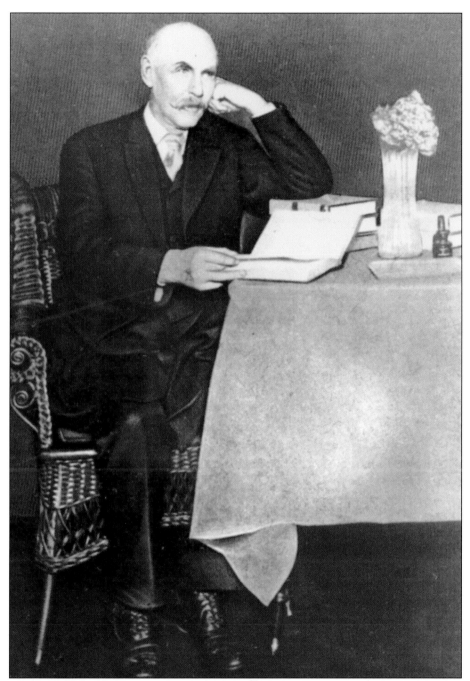

ASA SHINN MERCER (1839-1917), INVASION AUTHOR. Mercer's 1894 account of the Johnson County invasion, *The Banditti of the Plains, Or the Cattlemen's Invasion of Wyoming in 1892 (The Crowning Infamy of the Ages)*, is the earliest and arguably the most famous book dealing with that historic episode. Mercer originally came to Wyoming to edit the official publication of the WSGA. However, as the invasion events unfolded, he began to sympathize with the small ranchers. The distribution of the book's 1894 first edition is reported to have been actively suppressed by the WSGA. (JGMM.)

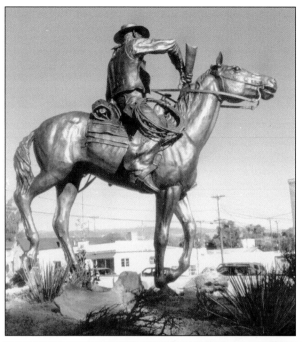

RIDING FOR THE BRAND. The statue shown at left depicts a cowboy pulling his Winchester rifle to challenge a small rancher branding a calf on the open range as shown on the facing page. The statues shown at left and on the facing page are located on South Main Street in Buffalo across from the First National Bank. These four photographs are courtesy of that bank.

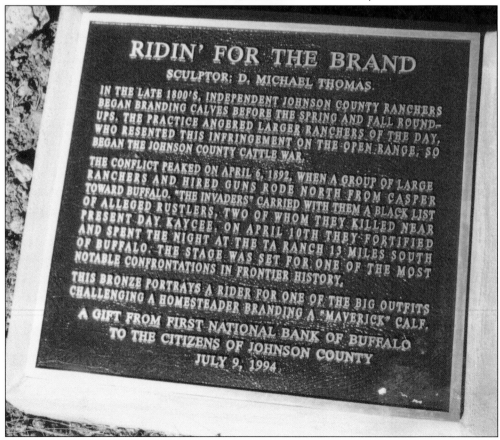

RIDIN' FOR THE BRAND

SCULPTOR: D. MICHAEL THOMAS.

IN THE LATE 1800'S, INDEPENDENT JOHNSON COUNTY RANCHERS BEGAN BRANDING CALVES BEFORE THE SPRING AND FALL ROUND-UPS. THE PRACTICE ANGERED LARGER RANCHERS OF THE DAY, WHO RESENTED THIS INFRINGEMENT ON THE OPEN RANGE, SO BEGAN THE JOHNSON COUNTY CATTLE WAR.

THE CONFLICT PEAKED ON APRIL 6, 1892, WHEN A GROUP OF LARGE RANCHERS AND HIRED GUNS RODE NORTH FROM CASPER TOWARD BUFFALO. "THE INVADERS" CARRIED WITH THEM A BLACK LIST OF ALLEGED RUSTLERS, TWO OF WHOM THEY KILLED NEAR PRESENT DAY KAYCEE. ON APRIL 10TH THEY FORTIFIED AND SPENT THE NIGHT AT THE TA RANCH 13 MILES SOUTH OF BUFFALO. THE STAGE WAS SET FOR ONE OF THE MOST NOTABLE CONFRONTATIONS IN FRONTIER HISTORY.

THIS BRONZE PORTRAYS A RIDER FOR ONE OF THE BIG OUTFITS CHALLENGING A HOMESTEADER BRANDING A "MAVERICK" CALF.

A GIFT FROM FIRST NATIONAL BANK OF BUFFALO TO THE CITIZENS OF JOHNSON COUNTY
JULY 9, 1994

58

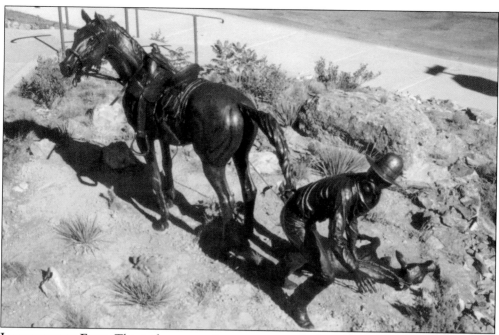

LIVING ON THE EDGE. This is the companion statue group to those shown on the preceding page. It portrays a rancher branding a "maverick"—an unbranded calf—on the open range.

LIVING ON THE EDGE

SCULPTOR: D. MICHAEL THOMAS

AN INDEPENDENT COWBOY, OR SMALL RANCHER, BRANDS A CALF ON THE OPEN RANGE. SURPRISED AT HIS WORK, HE TURNS TO SEE A RIDER FROM A LARGE CATTLE OUTFIT GALLOPING THREATENINGLY TOWARD HIM.

SMALL RANCHERS, LIKE THIS COWBOY, RODE SOUTH FROM BUFFALO ON THE MORNING OF APRIL 11, 1892, TO CONFRONT "THE INVADERS" AT THE TA RANCH. SHERIFF RED ANGUS, CITIZENS OF BUFFALO, AND SMALL RANCHERS LAID SEIGE TO THE GUNMEN. THREE DAYS LATER, TROOPS FROM FORT McKINNEY, NEAR BUFFALO, ARRIVED ON THE SCENE. THE INVADERS SURRENDERED AND WERE ESCORTED TO THE FORT, THEN SENT TO CHEYENNE. THEY WERE NEVER BROUGHT TO TRIAL.

A GIFT FROM FIRST NATIONAL BANK OF BUFFALO TO THE CITIZENS OF JOHNSON COUNTY
JULY 9, 1994

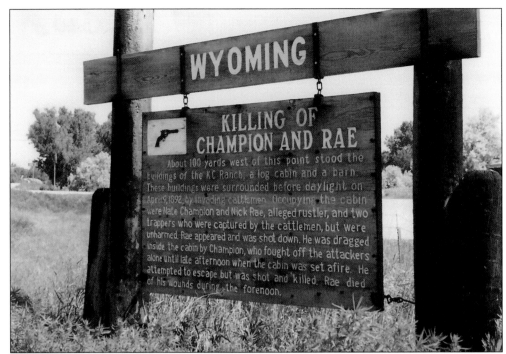

WYOMING

KILLING OF CHAMPION AND RAE

About 100 yards west of this point stood the buildings of the KC Ranch, a log cabin and a barn. These buildings were surrounded before daylight on April 9, 1892, by invading cattlemen. Occupying the cabin were Nate Champion and Nick Rae, alleged rustler, and two trappers who were captured by the cattlemen, but were unharmed. Rae appeared and was shot down. He was dragged inside the cabin by Champion, who fought off the attackers alone until late afternoon when the cabin was set afire. He attempted to escape but was shot and killed. Rae died of his wounds during the forenoon.

CHAMPION AND RAY REMEMBERED. As the first victims of the infamous invasion, Nate Champion and Nick Ray (Rae) occupy a special place in Wyoming history. Champion's incredible feat of single-handedly holding some 50 armed attackers at bay for hours and not yielding until his cabin was set on fire has evoked admiration from contemporary times to the present. He has been called "the bravest man in Johnson County." Champion and Ray are memorialized by a state marker near the KC cabin site (pictured above). The two cowboy defenders are buried next to each other in Buffalo's Willow Grove Cemetery (shown below). (Both, JCL.)

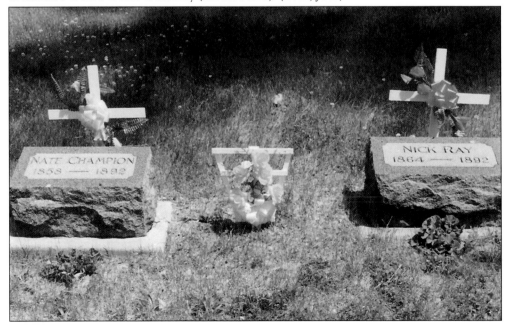

Four

Town and
Ranch Activities
1893 to the 1920s

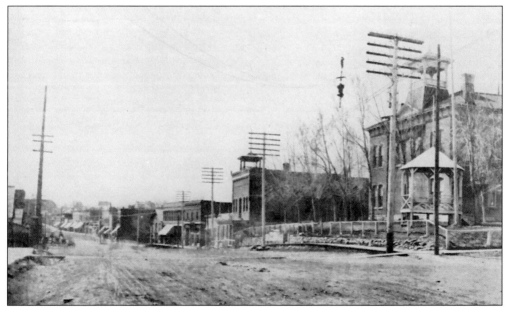

Electric Power and Telephone Poles. This late-1910s photograph shows telephone poles along Main Street. They have multiple cross members, each of which holds the wires for five circuits. Each circuit, in turn, handled up to 10 numbers on a party line. A German immigrant, Gustave A. Moeller, built the first telephone lines in Johnson County in 1901, sold the service to Bell Telephone in 1903, and became their Buffalo manager. Electric power poles are seen on the left (east) side of Main Street. (JGMM.)

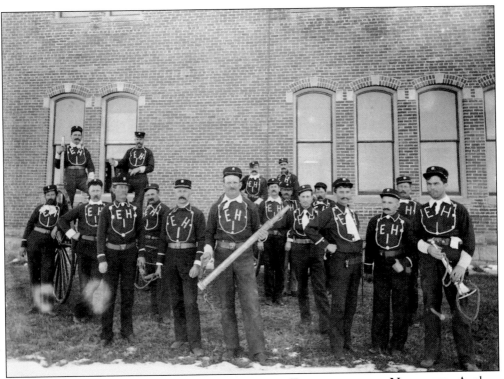

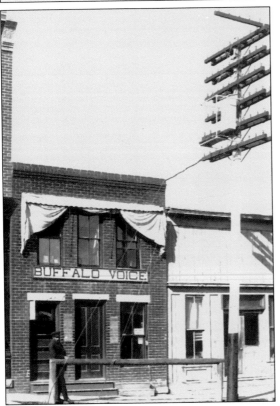

FIREFIGHTERS AND NEWSPAPER. As the 20th century neared, Buffalo had grown large enough that some type of fire protection was needed, especially for the closely spaced downtown buildings. The early firefighters were volunteers, as depicted in the photograph above of the uniformed Engine and Hose Company, labeled the "1st in Buffalo." Their equipment was a hose carriage and a water tank–pump unit of some type; the leftmost firefighter is leaning on one of its wheels. The early-1920s photograph at left shows the *Buffalo Voice* building on Main Street. That newspaper was published from 1897 to 1925. It had previously been the *People's Voice* (1892–1897) and the *Buffalo Echo* (1883–1892). In 1925, the *Voice* became the *Buffalo Bulletin*, which continues to the present. The photograph label states that the telephone exchange is located on the second floor. That would account for the large number of cross members and transformer on the adjacent telephone pole. (Both, JGMM.)

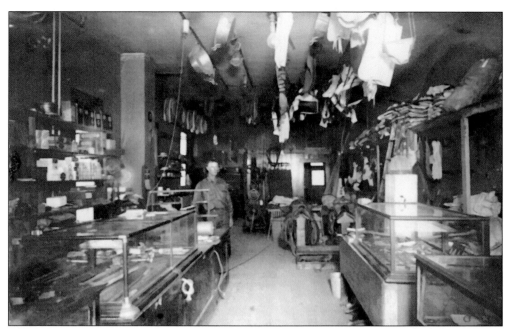

SADDLE AND HARDWARE STORES. Two of a ranching community's essential stores—a saddlery and a hardware shop—are pictured here. Both were located on Main Street during the early 1900s. The photograph of Percy A. Wilkerson's Saddle Shop above indicates an extensive line of merchandise in addition to saddles. Not one to miss an opportunity, Wilkerson opened a soft drink parlor in the 1920s at the onset of Prohibition. It was reputed to have developed into a speakeasy source of moonshine. The Tompkins and June hardware store is shown below complete with one of the owners wearing a vest, some customers, and a board sidewalk in front. The store ran a 1907 advertisement in the *Buffalo Voice* stating, "The finest line of buggies in Northern Wyoming carried in stock." (Both, JGMM.)

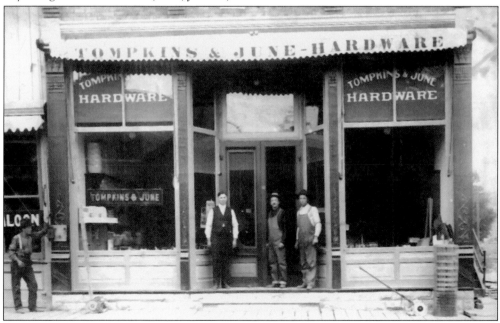

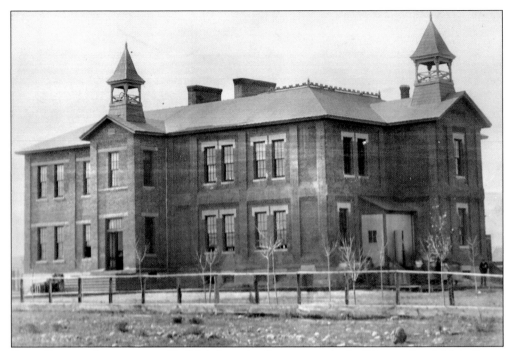

EARLY BUFFALO SCHOOLHOUSE. Buffalo's first schoolhouse was a log building on South Main Street in 1881. In 1886, a brick structure, seen above, was completed on Fort Street at a cost of $15,000. Beginning in 1892, high school classes were held on the second floor of that building. Near the beginning of the 20th century, the grade school had four teachers and a principal, R. L. Hogg. The structure was completely gutted by a fire in 1906, thought to be due to a defective furnace, and was replaced in 1907. The photograph below depicts the student body and faculty sometime prior to the 1906 fire. (Above, JGMM; below, JCL.)

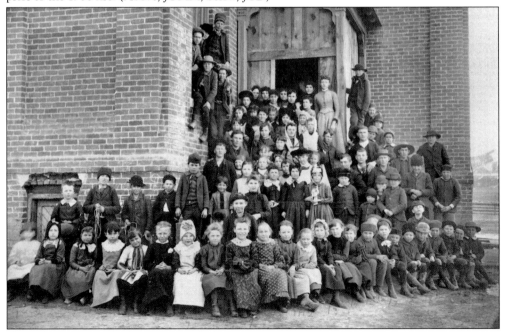

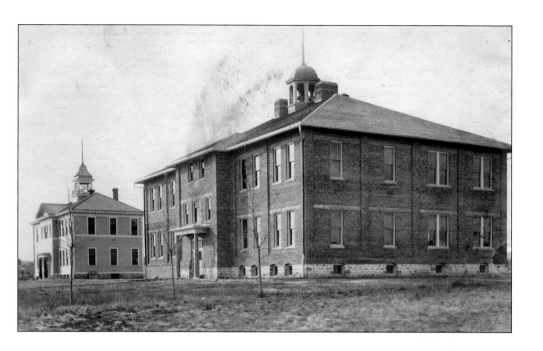

BUFFALO SCHOOLHOUSES, 1907 AND 1911. The replacement school buildings noted in the preceding caption are depicted in the photograph above. There are now both grade and high schools, but the dating of the second school building, a separate high school, is uncertain. It was, however, replaced in 1911 with a new structure (seen below). That building served until 2007, when it was razed and a replacement built south of town. (Above, JGMM; below, BBN.)

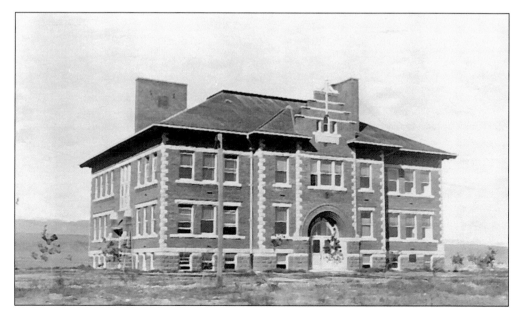

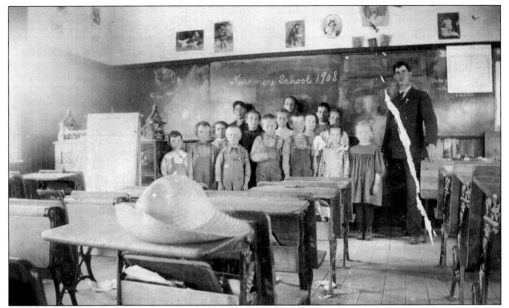

OUTLYING SCHOOLS. In the early 1900s, the distances to outlying ranches, available transportation, and severe winter weather prevented ranch children from attending school in Buffalo. This problem was, of course, statewide. In response, Wyoming developed a system of small schools on an individual ranch located near one or more other ranches with school-age children. Qualified teachers were hired, and they received room and board during the school year at one of the participating ranches. Teachers and students from two of those Johnson County schools are pictured here. The photograph above is for the Kearney School, northwest of Buffalo, in 1908, and the one at left is for the Ninemile School, south of Buffalo, in 1917. (Above, JGMM; left, BBN.)

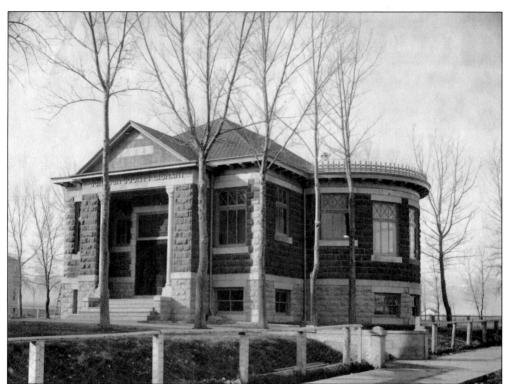

COUNTY LIBRARY AND CITY HALL. The first library in Buffalo, around the start of the 20th century, was located in a South Main Street building originally built in 1887 as a men's clothing store. In 1909, the Carnegie Foundation built the Johnson County Library (pictured above) next to the courthouse at Main and Fort Streets. The design was typical of the more than 2,500 Carnegie Libraries nationwide, and its construction was of locally quarried red sandstone blocks. It served as the county library until 1988, when a larger structure was built, and then became part of the Jim Gatchell Memorial Museum. It remains so to the present. A city hall was constructed in 1901. It also housed the fire department and the jail. The roof cupola held a large bell used to sound a fire alarm. The structure was demolished in 1973. An adjacent brick structure was built o serve as the new city hall. (Both, BBN.)

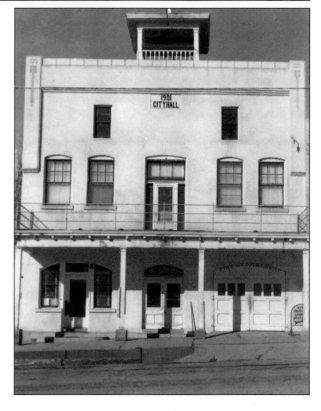

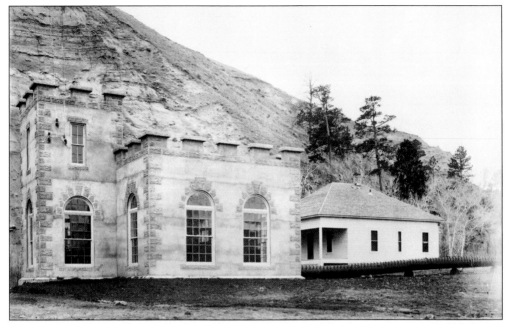

NEW ELECTRIC POWER PLANT. By the early 1910s, the demand for electric power in Buffalo began to exceed the capacity of the small hydroelectric plant in the flour mill at Buffalo. In 1914, a new plant was built (pictured above); there also was a hydroelectric facility on Clear Creek located 7 miles west of town at the base of the mountains. Operator Marshall W. Bell's white house is seen next to the plant building. Additionally, a dam was built across Clear Creek (shown below) to ensure a steady water supply. The water was delivered from the dam to the dynamo by means of a large wooden pipe, shown on the ground in front of the operator's house adjacent to the power plant. Upon exit from the plant, the water was then piped on to Buffalo for town use. The plant was purchased by the Mountain States Power Corporation in 1929. It was subsequently sold to the Pacific Power Corporation, who operated it for a number of years. It is no longer in operation. (Both, BBN.)

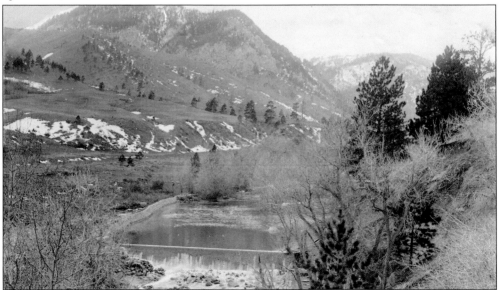

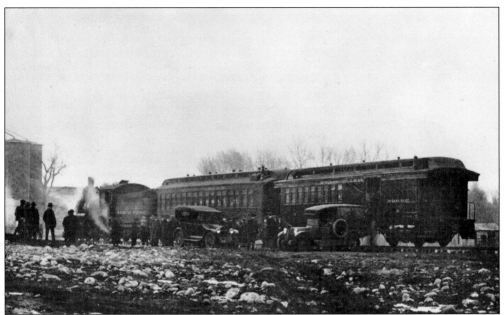

THE WYOMING RAILROAD. The Burlington Railroad bypassed Buffalo in the early 1890s, and the community continued to be what was then known as an "inland town," that is, a town with no railroad connection. In those times, that was considered to be a detriment because it meant continued dependence on stagecoaches, freighting, and trail drives. That status ended in 1918 when the Wyoming Railroad made its initial run from Buffalo (pictured above) to the Burlington terminal at the Clearmont community some 29 miles to the northeast. The subsequent service over the years varied from good to sporadic as the railroad's bed and track were sometimes not well maintained and the winter weather could be severe. The line was locally called the BC&BM—Buffalo, Clearmont, and Back, Maybe. The photograph below shows the old (colt) and the new (locomotive) forms of transportation at the Buffalo siding. The Wyoming Railroad was a considerable asset to Buffalo and served that community until 1945. (Both, JGMM.)

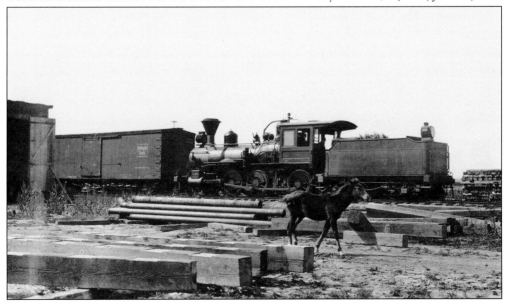

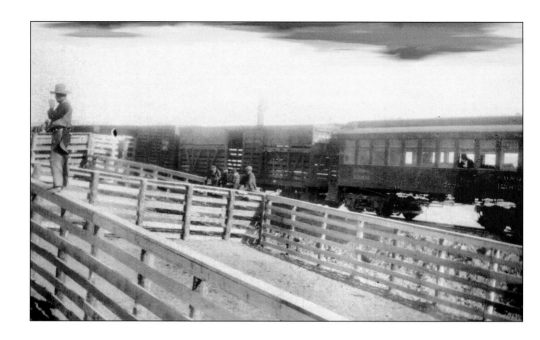

LOADING LIVESTOCK AND CROPS. Freight transport was, of course, the Wyoming Railroad's principal source of income. Early in the construction period, stock corrals (pictured above) and beet dumps were made. The livestock being shipped were cattle and sheep, while sugar beets, destined for the Holly Sugar Mill in Sheridan, were the principal agricultural product. The rate was 45¢ per hundred-weight for the Buffalo-Clearmont haul, which was advertised as 30¢ per hundred-weight savings over the same trip by freighting. The photograph below shows beets being loaded, away from the Buffalo terminal dump, directly from a farmer's wagon. (Both, JGMM.)

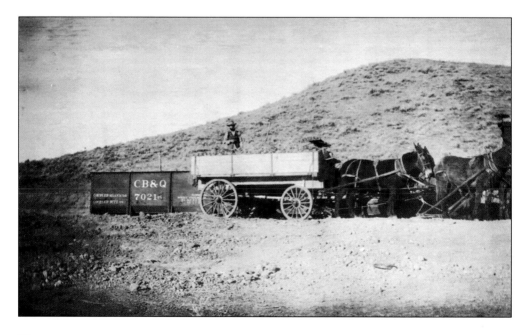

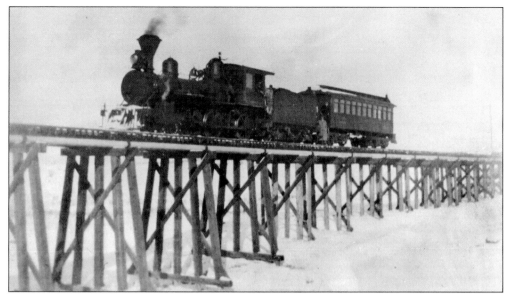

RAILROAD TRESTLES. There were 40 trestles needed in the 29 miles of rolling prairie between Buffalo and Clearmont. Most were small but some, of course, were sizeable like the one pictured above, and they were generally well made. In 1946, however, some loose rails spread apart as Engine No. 102A was crossing a high trestle 12 miles east of Buffalo. When the 90,000-pound locomotive was set forcefully onto the timbers, they gave way, and the engine crashed to the bottom of the draw (shown below). It caught fire, damaging the cab and injuring the engineer, D. Marvin Holt. The man and the locomotive survived, but the railroad did not. It had been facing declining revenues for some time, and the following year, 1947, it filed for bankruptcy, which was granted. The line, however, was unable to get back into operation and faded into obscurity. (Both, JGMM.)

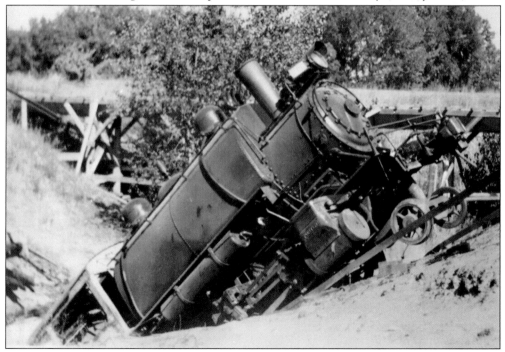

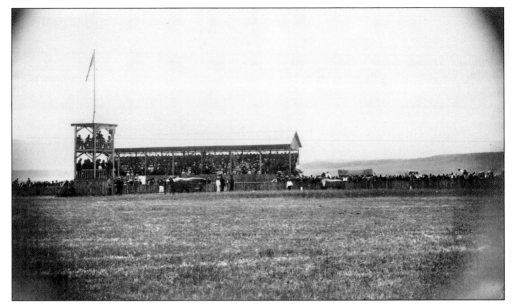

FAIRGROUNDS. Photographs of judging and exhibits at the first Johnson County Fair in 1887 were shown in chapter two. Shown here are a 1900 panorama view of Buffalo's grandstands and judges' tower (pictured above) and a 1904 photograph of the attendees inside and in front of the grandstand (shown below). What year the fairgrounds buildings were constructed is uncertain. Dedicated fairgrounds became a conventional practice in this country and abroad. In addition to seating for the public and the judges at an arena, a number of supporting facilities were also needed: livestock and agricultural exhibit buildings, livestock barns, stalls and pens of various types, pavilions for special events, and more. (Both, JGMM.)

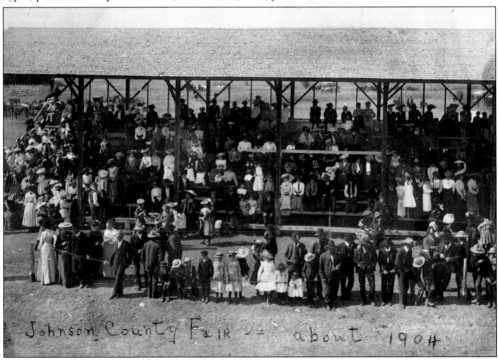

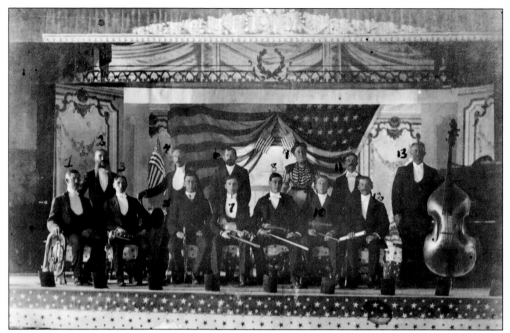

MUSIC AND THEATER. The Buffalo community in the early 1900s was particularly active in the musical and performing arts. This is perhaps expected given the virtual absence of commercial entertainment. It is, however, quite clear that there were some talented individuals living in the town. The photograph above is of the 1902 Buffalo Philharmonic Orchestra. The Gatchell family men were all members: P. A. Gatchell (2), vocalist and Jim's father; Frank Gatchell (3), coronet, Jim's brother; and Jim Gatchell (7), first violin. The photograph below records a scene from a 1904 play, *Nevada or the Lost Mines*, presented in city hall. In addition to musical presentations, there are records of ongoing masquerade balls, dancing parties, minstrel groups, parlor concerts, and more; quite a bit of culture for the northern Wyoming prairie. (Above, JGMM; below, OHM.)

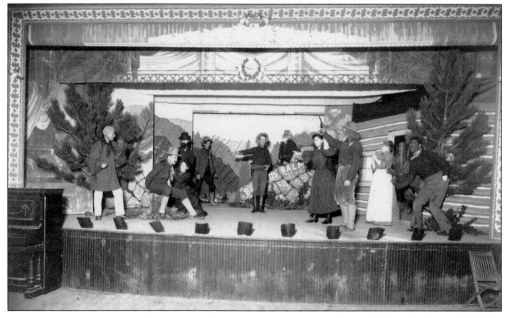

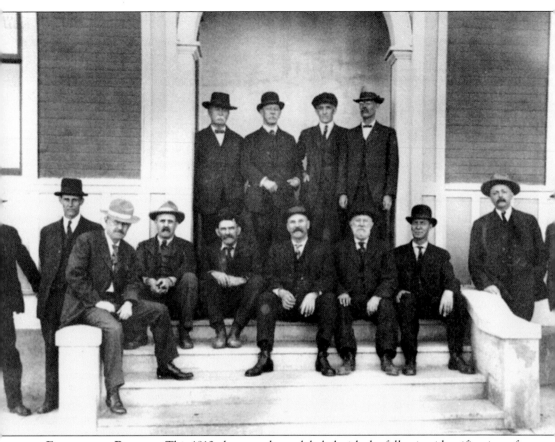

FOUNDERS OF BUFFALO. This 1912 photograph was labeled with the following identifications: from left to right, (first row) J. C. Van Dyke, Gray Norval, W. J. Thom, Alex Laing, M. T. Redman, Billy Adams, George "Pap" Myers, S. B. Cochran, Charles Rand, and T. James Gatchell; (second row) W. G. "Red" Angus, Judge C. H. Parmelee, Dave Young, and T. P. Hill Sr. (JGMM.)

THE WYOMING STATE FLAG DESIGN. Buffalo resident Verna Keyes designed the Wyoming state flag in 1916. There was a statewide contest sponsored by the Daughters of the American Revolution that year that was open to everyone. Keyes, at right, had just graduated from the Art Institute of Chicago, and her father urged her to enter the competition. She did, and her design was chosen from a field of 37 entries. Keyes explained her basic symbolism as the Great Seal of Wyoming as the heart of the flag; the bison was the monarch of the plains; the red border for the Native Americans; white for purity; blue for Wyoming skies and as the symbol for fidelity, justice, and virility. In January 1917, the 14th Wyoming Legislature adopted the design, and in 1920, a folder describing the flag with a picture of it was given to each schoolchild in the state. The photograph below depicts Verna Keyes Keays holding her winning flag design. (At right, JCL; below, JGMM.)

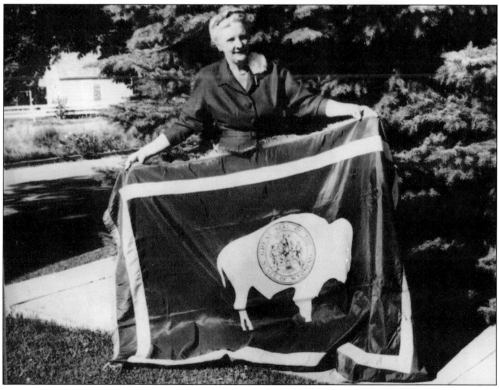

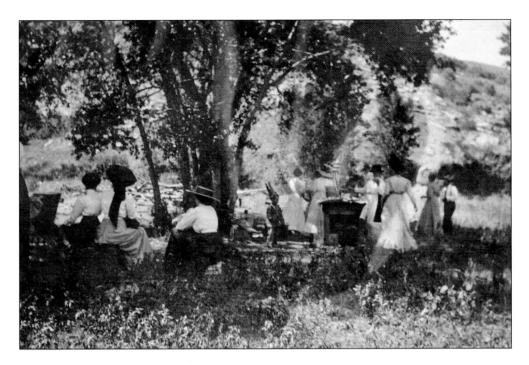

FOURTH OF JULY CELEBRATIONS. What could be more typically American than Fourth of July picnics and parades? Two such celebrations by Buffalo residents are shown here. A 1909 picnic attended by nicely dressed ladies and gentlemen beneath large cottonwood shade trees along Clear Creek is depicted in the above photograph. The illustration below is of decorated vehicles gathered alongside the county courthouse in 1918. The decorations, Red Cross vehicles, and floats are probably in support of the ongoing World War I. (Both, JGMM.)

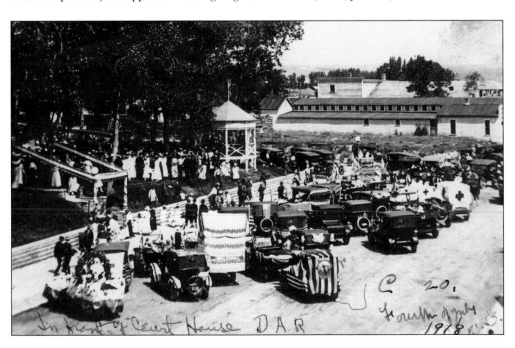

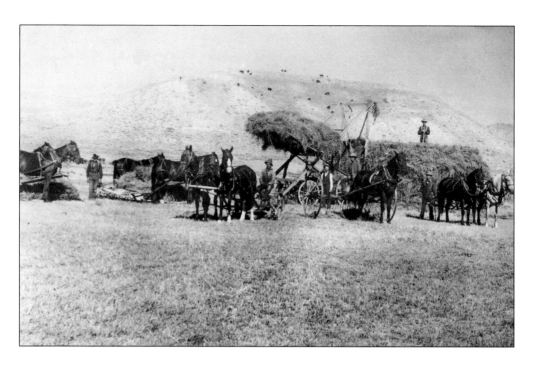

HAYING OPERATIONS. Those essential, early-20th-century "hayburners"—horses and cattle—required large amounts of the dry grass to see them through the long Wyoming winters. Both town residents and some of the outlying ranches needed to buy hay for their stock. To supply those needs, a large number of water rights filings were made on Clear and Rock Creeks and Powder River. Their principal purpose was irrigation to grow hay as a commercial crop. A 1900 hay operation on the Capps Ranch along Clear Creek (pictured above) and the haying crew at their chuck wagon (shown below) are captured in these photographs. (Above, BBN; below, JGMM.)

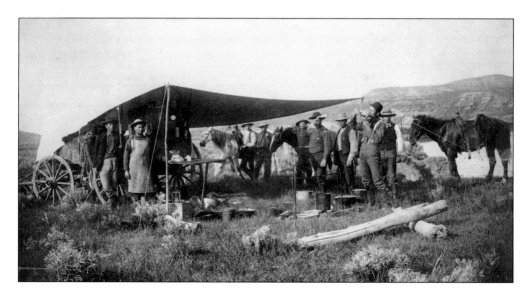

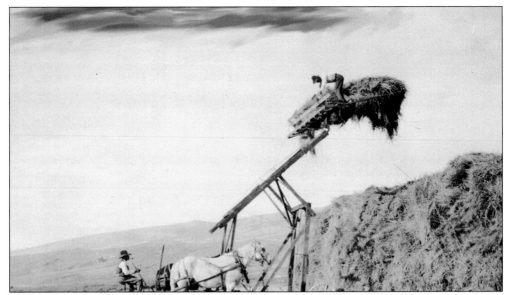

MORE HAYING OPERATIONS. Hay was not baled in the early days but was gathered into large stacks. The first mechanical hay balers were invented in the 1850s but were not widely available for quite some time. An early technique suitable for haying in many different areas was a Sweep Rake–Overshot Stacker combination. The rake swept the hay onto the forks of the overshot stacker, which were mounted to two long, hinged arms. A pulley-and-cable system was powered by horses to raise the arms up and over the stack and dump the new load on top of the haystack. That equipment and process is shown in the two photographs here at the Buell Ranch outside Buffalo. (Both, JGMM.)

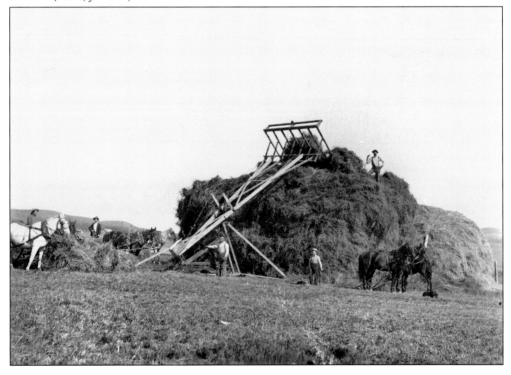

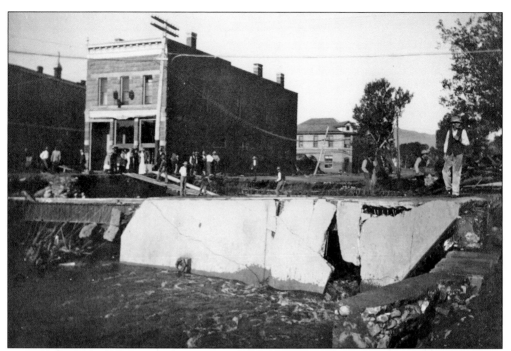

FLOOD OF 1912. At twilight on June 11, 1912, the normally tranquil Clear Creek reached flood stage and swept through Buffalo's downtown area, causing the death of resident Robbie Childs. The concrete bridge was destroyed (pictured above), buildings were moved off their foundations and set afloat, and the streets were covered with layers of mud and debris (shown below). The city's dynamo was wrecked, and town residents were without power for several weeks. The total damage was estimated at $500,000. The cause of the flood was attributed to a "massive cloudburst" that occurred between the Big Horns and the Soldiers and Sailors Home (old Fort McKinney). (Both, JGMM.)

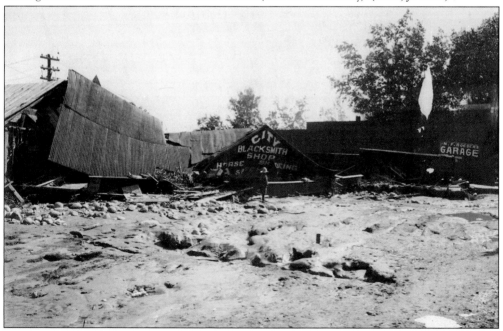

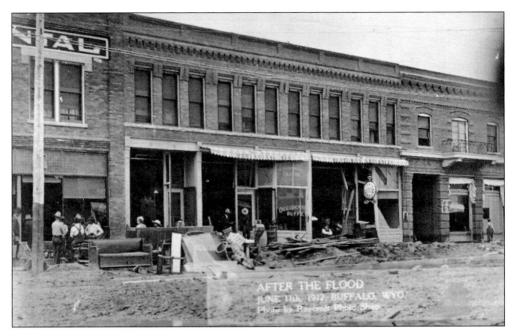

FLOOD OF 1912 CONTINUED. The Occidental Hotel, located next to Clear Creek, incurred some $10,000 in total damages (pictured above). Young's Jewelry store was located next to the Occidental and advertised with a large pocket watch sign above the sidewalk. It was particularly hard hit (shown below), and its costly merchandise was swept downstream. There are stories of adults and children subsequently "panning for gold" in the downstream mud and silt. The floor at Gatchell's Buffalo Pharmacy was covered with 18 inches of water that deposited some 6 inches of mud, and its cellar was, of course, filled with water. Total damages were about $3,000, but Jim had the drugstore back in operation in three days. (Both, JGMM.)

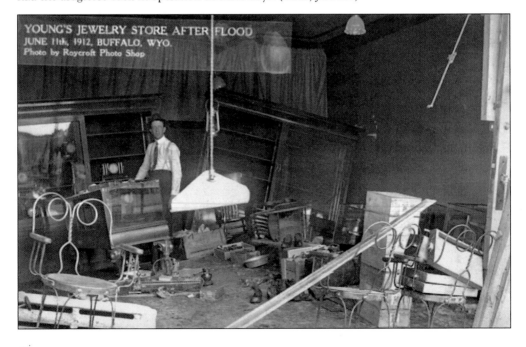

OUTLYING POST OFFICES. As county seat, Buffalo has the principal post office in Johnson County. However, during the early 20th century, many of the smaller communities also maintained federal post offices named for their communities. There were, for example, post offices at Mayoworth (1889–1944, pictured above in 1909), northwest of Kaycee, and at Barnum (1889–1940, shown below in 1918), southwest of Kaycee. These and similar rural post offices served residents in the surrounding, sparsely populated area of homesteads and ranches. The reason for the gathering at the Mayoworth Post Office is not known—a Sunday community group photograph perhaps? (Both, JGMM.)

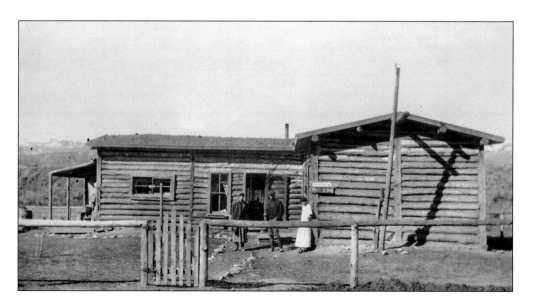

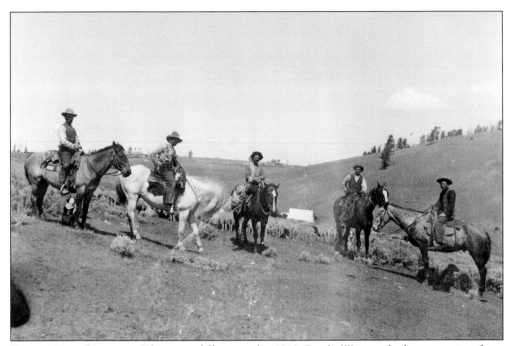

EARLY-1900s COWBOYS. The years following the 1892 Cattle War marked a transition from primarily open-range cattle grazing by a relatively few large ranchers to the same range being fenced and used by multiple smaller outfits. More farmers and ranchers there began irrigating land for hay and grain crops. Cattle prices were high in 1900, and the number of Johnson County cattle grew to exceed 30,000. They would then vary between 26,000 and 55,000 over the next two decades in response to market prices and climate variability. Cowboys remained the primary workers (pictured above), and they continued to sleep in the open when working cattle (shown below). Their equivalent of today's down sleeping-bag in a nylon tent was a bedroll of blankets wrapped in a canvas cover. Note that one of the cowboys is awake and keeping an eye on the photographer. (Both, JGMM.)

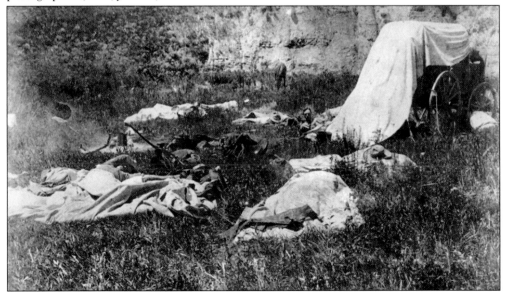

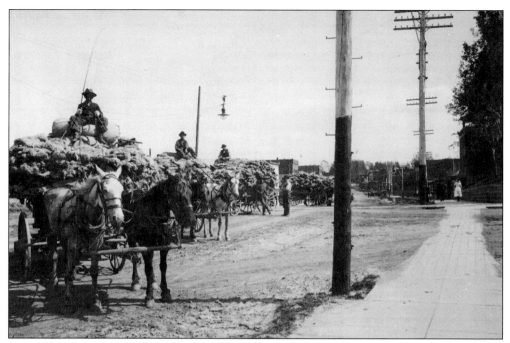

SHEEP RAISING, EARLY 1900S. Raising sheep during this period began demonstrating a higher profitability than cattle ranching. Thus as the number of large, open-range operations declined, a pronounced increase in sheep raising began in Johnson County. By 1900, there were 200,000 sheep in the county, and in 1902, some 1.5 million pounds of wool, termed sheep pelts, was freighted out of Buffalo (pictured above). As the numbers of sheep increased, the ranchers leased available forest pastures and grazed sheep there in the summer (shown below). A peak in the number of sheep in the county was 327,500 in 1909. From then until 1920, their numbers hovered at about the 180,000 level. (Both, JGMM.)

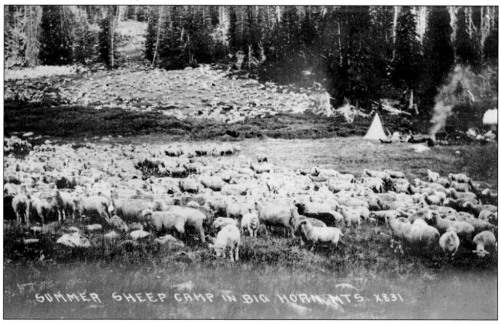

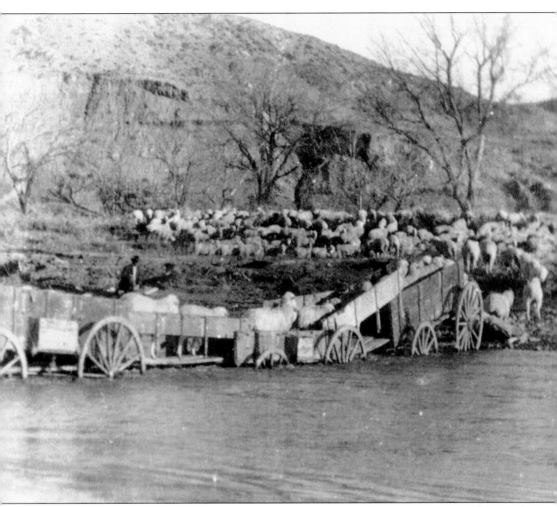

Sheep Crossing a Stream. Cattle and horses can usually swim across streams and rivers, but sheep, because of their heavy wool coats, cannot. That problem was solved by shepherds, when the water was not too deep, by making a bridge of their wagons as depicted here. The end and tail gates were lowered, and planks and side boards were used as guides between wagons. (JGMM.)

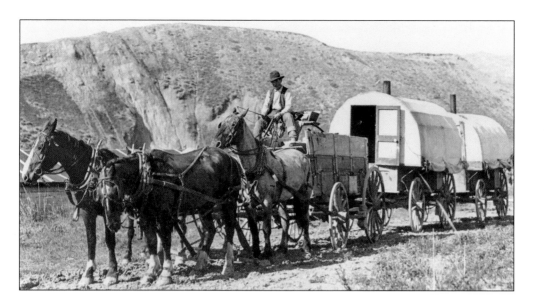

SHEEP WAGONS. The sheep wagon was a mobile, efficient, and quite comfortable home for the herder as he followed his flocks on their annual grazing cycle. The size was 11 feet long by 6.5 feet wide, covered by a layered canvas top, with a door at the front (tongue end) and a small window at the rear end. Below that window was a bunk about 4 feet above the floor with a pullout table and cabinets underneath. On the right side, next to the door, was a stove for cooking and heating. The left side had another bench, again with cabinets below, that served as a general work and wash area. The herder was visited by a camp tender every 10 days or so to deliver supplies. Pictured above are sheep wagons heading out for a season's work. Very large flocks would be divided between multiple wagons to graze different areas. (Above, BBN; below, JGMM.)

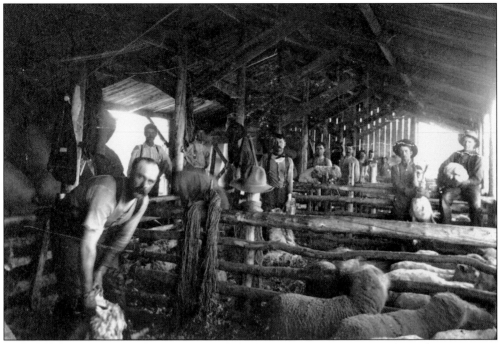

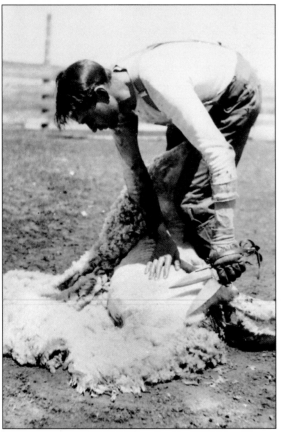

SHEEP SHEARING. Sheep shearing is harvesting the owner's wool crop by removing the woolen fleece from his sheep. Typically that shearing is done once a year by a shearer in specially designed shearing sheds (pictured above) or pens. An efficient shearer can "tally" more than 200 sheep per day. Originally, manual blades shears (shown at left) were used. Now they are used only when electricity is not available, for special treatment of stud rams, or to leave somewhat more after-shearing wool on the sheep for protection in very cold climates. Machine shears, termed hand pieces, were initially driven mechanically but were later powered by electricity. The Tri-County Electric Association, Inc., and the Sheridan-Johnson Rural Electrification Association, Inc., brought electricity to northeastern Wyoming ranches in the mid-1940s. (Above, JGMM; left, JCL.)

Five

PHARMICIST AND COLLECTOR JIM GATCHELL
1900 TO 1954

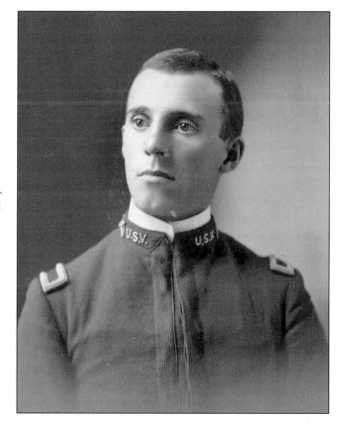

THEODORE JAMES GATCHELL (1872–1954). A somber 2nd Lt. Jim Gatchell in 1898 is pictured here. During the Spanish-American War, he was 26 years old. On enlistment, he was attached to Troop E of the 2nd Wyoming Volunteers—note the U.S.V. on his collar. In the fall of 1898, Gatchell accompanied his troop to Jacksonville, Florida, for departure to Cuba. However, the war ended before they sailed, so they returned home, and none of them saw action in that island country. (JGMM.)

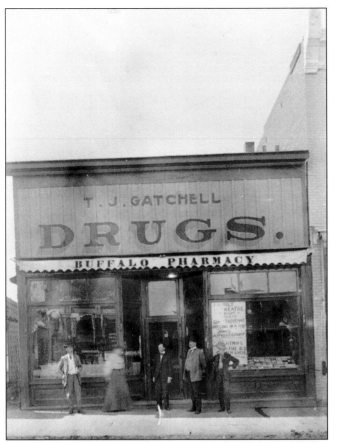

THE BUFFALO PHARMACY, EARLY 1900S. The photograph at left depicts the front of Gatchell's Buffalo Pharmacy, which he opened in February 1900. The people shown are unidentified. The photograph below is of the interior of the Gatchell Pharmacy and may have been in that same building. However, Gatchell moved his business to a larger space in 1903 and stayed there until a final move was made in 1907. All three locations were on South Main Street. About 1914, Jim changed the name of his business to the Gatchell Drug Store. He continued to serve as the Buffalo community's pharmacist until his death in 1954. (Left, JGMM; below, JCL.)

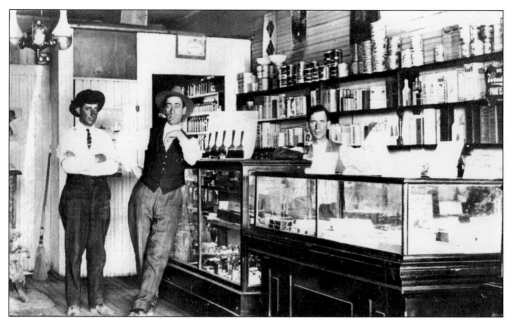

THE BUFFALO PHARMACY, 1909. Portrayed here is the inside of the Gatchell Pharmacy with Jim's brother, Albert, behind the counter. The man on the left is unidentified, and on the right is Gray Norval. This is the final location of Gatchell's business, and it was kept open by the family until 1987. Currently, the building space houses a gift shop. (JCL.)

EARLY DRUGSTORE WALL ARTIFACT COLLECTION. Gatchell's frontier artifact collection increased in number over time, mostly by gifts from his rancher and Native American friends. His compassionate personality plus health care services as a druggist made it easy for individuals to want to express their thanks by giving him heirlooms and special possessions. Gatchell began displaying his growing collection on the walls of his drugstore. They were an effective attraction to bring potential customers into his store because there was no museum in town. This early photograph has Jim explaining an antique rifle to some friends. (BBN.)

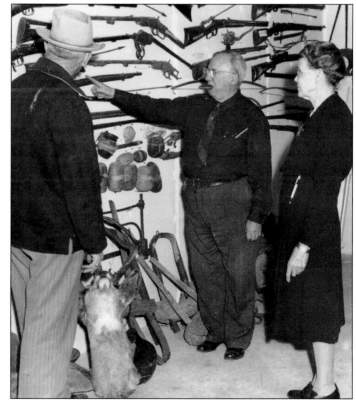

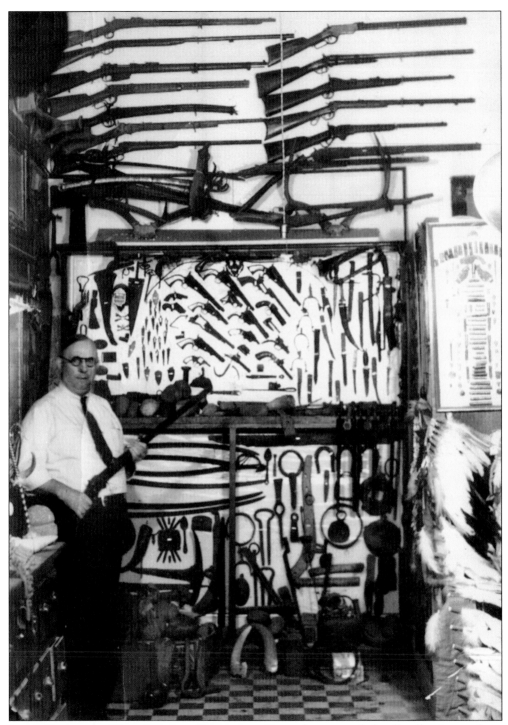

LATER DRUGSTORE WALL ARTIFACT COLLECTION. Jim and an expanded wall collection, perhaps in the 1930s, are illustrated here. This is judged to be the latest such picture in the drugstore that is available. The final phase for the collection's exhibition was in a back room, separated from the store proper, but no photographs of it have been found. (JGMM.)

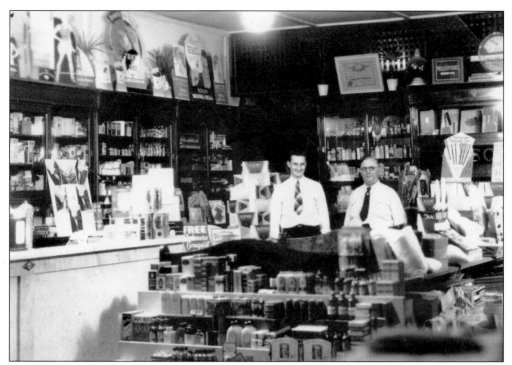

THE GATCHELL DRUG STORE. The interior of Gatchell's drugstore is shown in this 1930s or 1940s photograph. To Jim's right is employee Leonard Roudenbush. In addition to drugs and medical supplies, the store sold a broad line of personal items, as do present-day drugstores. What was unusual, perhaps, were the veterinary products that were also available for the ranchers and farmers' livestock. It is not well known, but Gatchell was a veterinarian in addition to being a pharmacist. He earned a state certification in both professions. (JGMM.)

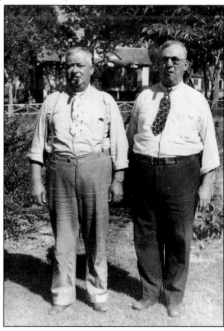

GATCHELL AND FRIEND. These two look-alikes are Jim Gatchell (right) and his friend Alex Kerr. Gatchell was once described by a writer as having a "Santa Claus figure." That would obviously also apply to Kerr, owner of the Buffalo Greenhouse. A dominant habit of Jim's, the one most often mentioned by his friends, was an ever-present, unlit cigar in his mouth. Kerr seems to be similarly inclined but on the opposite side of the mouth from Jim. (JGMM.)

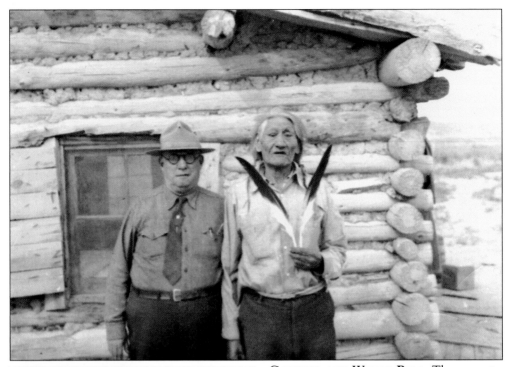

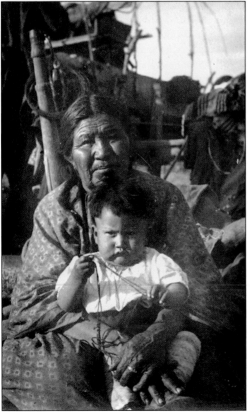

GATCHELL AND WEASEL BEAR. The nearest Native American reservations to Buffalo are just north of the Wyoming-Montana border and are home to the Crow and the Northern Cheyenne. Pharmacist Jim Gatchell learned the Plains Indians' sign language and was able to converse freely with them when they visited Buffalo. He quickly became a friend and helped them with medicines and also on a wide range of other issues. He was given the Cheyenne name "Turpy," which means "He who speaks for them." A special friend of Jim's was Weasel Bear, seen above. There is a story that when Weasel Bear came to Buffalo, he would go directly to the Gatchell Drug Store, be given a cigar, and then sit down on the floor of the store to smoke it. When he was finished, he would simply get up and leave. Weasel Bear's wife and grandson are shown at left. (Both, JGMM.)

GATCHELL AND JOHN ISSUES. Another of Jim's Cheyenne friends was John Issues (right). He has been referred to in print as a chief but that is not certain—it could simply be due to the fact that he is pictured wearing an eagle-feather war bonnet. Issues gave Gatchell a number of important gifts. One that remains on exhibit today at his namesake museum is a Mills Cartridge Belt, dated to the late 1870s, made of 46 brown canvas loops with a brass buckle and a leather tongue. Issues is pictured with his family below. (Both, JGMM.)

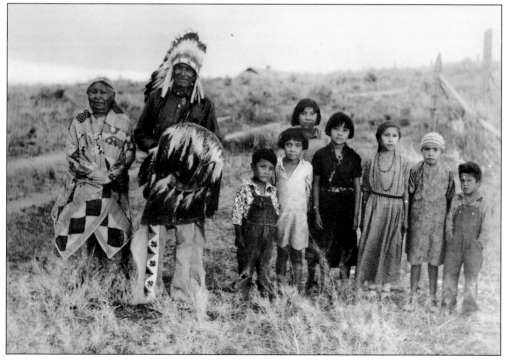

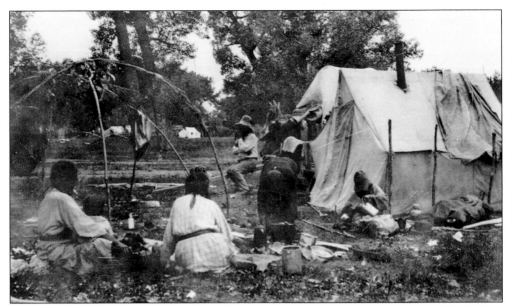

INDIAN CAMP ABOVE BUFFALO, 1920s. The camp scene shown here, located near Buffalo, is probably of a Cheyenne family on their way to or from a trading visit at Buffalo. At this time, they traveled by horse and wagon, and camped in canvas tents as depicted. While in Buffalo, they would set their tents up along Clear Creek in town. In addition to their trading, local folklore states that they also did quite a bit of asking for handouts, particularly of food. (JGMM.)

GATCHELL FIELD TRIP, 1930s. The individuals shown in this photograph are, from left to right, unidentified, Jim Gatchell, Hard Robe (who had been a Cheyenne army scout), and J. C. Van Dyke, a Buffalo businessman. Unfortunately, no one knows what this unusual group of men is up to or where they are. A reasonable guess would be visiting one of the nearby Indian War battle sites with Hard Robe as the tour guide. (JGMM.)

GATCHELL AS PUBLIC SPEAKER. Gatchell developed a reputation as a local historian and must have also been an effective public speaker because he was often asked to speak at dedications and other celebrations. The photograph at right is of Gatchell (left) and an unidentified companion at the dedication of the DeSmet Monument in 1940. The 18-foot-tall stone monument is at DeSmet Lake, seen in the background, several miles north of Buffalo. Pierre DeSmet (1801–1873) was a Jesuit missionary to the Native Americans during the 1840 to 1870 time period. In 1851, he was traveling to the Fort Laramie Treaty Council, and when passing a beautiful lake en route, his traveling companions named it after him. The photograph below has Gatchell giving a speech at Buffalo's 1941 Fourth of July Celebration. (Both, JGMM.)

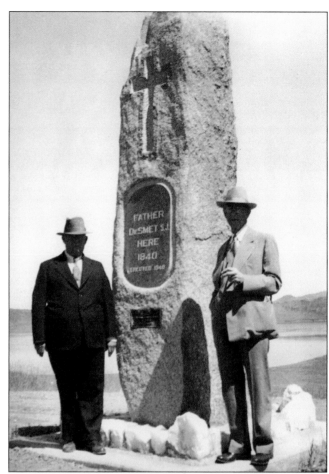

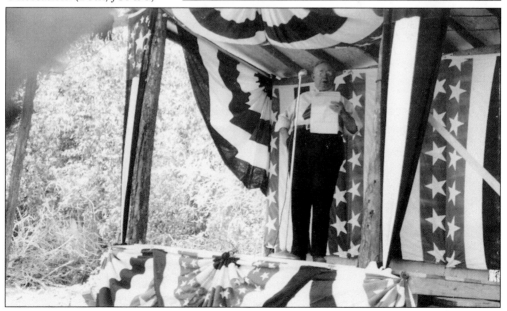

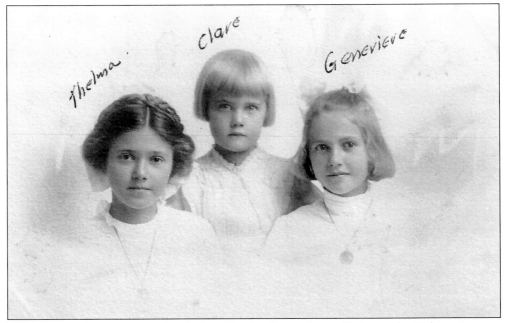

GATCHELL AND FAMILY, 1950. Gatchell and his family are pictured below at the 50th anniversary of his Main Street drugstore in 1950. Jim and his wife, Ursula Sackett Gatchell (1877–1964), are standing in front of their daughters, from left to right, Clare Gatchell Quale (1908–1990), Genevieve Gatchell Lester (1904–1990), and Thelma Gatchell Condit (1901–1966). This interior drugstore picture was taken just four years before Jim's death at the age of 82. The picture above is of the three Gatchell girls as lovely youngsters. (Above, JGMM; below, JCL.)

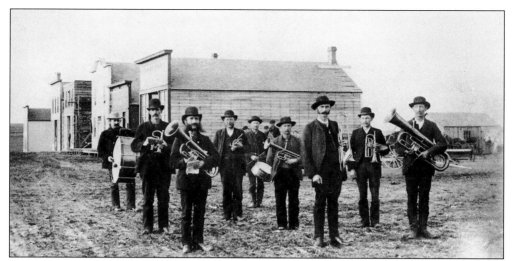

GATCHELL'S FATHER. Jim's father had an unusual first name, Prince Albert (1841–1925), which was neither a title nor a nickname. Born in Maine, he had an extensive and wide-ranging career: Civil War captain, attorney in Wisconsin, and, for 25 years, newspaper publisher in Minnesota, Nebraska, and Sheridan, Wyoming. Moving to Buffalo, he served as registran of the U.S. Land Office, justice of the peace, postmaster, and finally adjutant general of the Wyoming National Guard. He wore a distinctive beard style termed a "Franz Josef" after the 19th-century emperor of Austria. An accomplished musician, he played baritone saxophone in Buffalo's first band (above, first row, left) and was vocalist for the Buffalo Philharmonic Orchestra. The photograph below shows him (first row, second from left) at a reunion of Civil War veterans in Buffalo (date unknown). (Above, JGMM; below, JCL.)

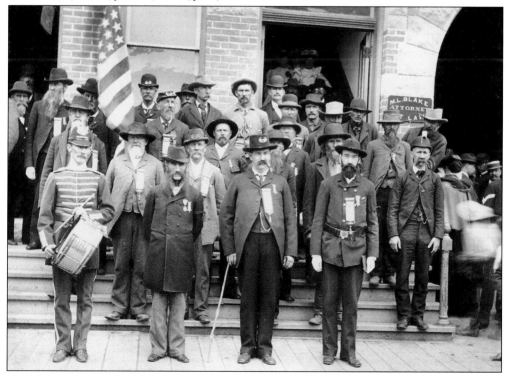

THE JIM GATCHELL MEMORIAL MUSEUM. Following Jim Gatchell's death in 1954, the family offered his superb collection of some 1,500 artifacts to Johnson County on the condition that they build a museum to adequately display and conserve them. The county residents accepted, and three years later, in 1957, the Jim Gatchell Memorial Museum was opened. To Jim's collection, a large number of artifacts, heirlooms, and memorabilia were donated by county ranchers, farmers, and town residents, thereby making the new museum truly representative of their history and culture. The photograph above depicts an early-1960s exhibit of frontier rancher items. The museum's grassroots connection continues to the present and accounts for the appeal of this exceptional history museum. Over time, the museum (shown below) has grown and developed professionally to the stage where it achieved national accreditation in 2002 and celebrated its golden anniversary in 2007. (Both, BBN.)

Six

CONTINUED
ECONOMIC DEVELOPMENT
THE 1920S AND LATER

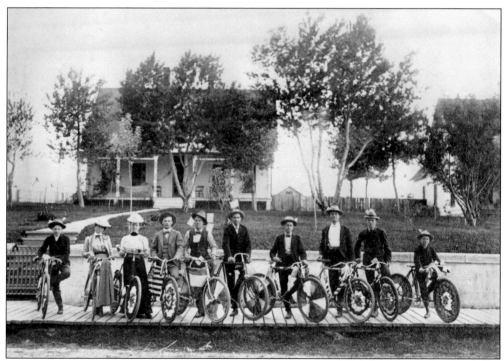

BUFFALO BICYCLE CLUB, 1920S. The cyclists depicted are certainly dressed for an occasion and have decorated their bicycles with colored—probably red, white, and blue—crepe paper. That occasion is almost certainly a Fourth of July parade. Note the board sidewalk and unpaved street. Buffalo's Main Street was not paved until the mid-1930s, and the side streets were hard-surfaced much later. (BBN.)

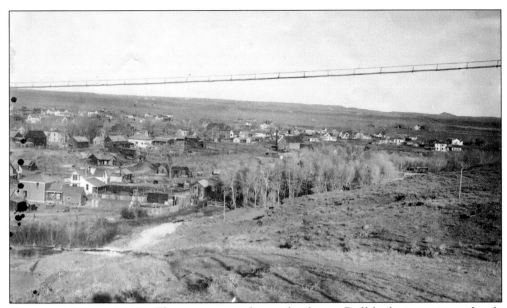

BUFFALO, 1930S OR 1940S. These two views show a developing Buffalo during or immediately following the Great Depression years. The photograph above documents the growth in number of houses that has occurred. Clear Creek and its bordering trees are in the foreground with power and telephone lines visible against the sky. Below, the town appears to be prospering in that there are quite a number of automobiles on Main Street. (Above, BBN; below, JGMM.)

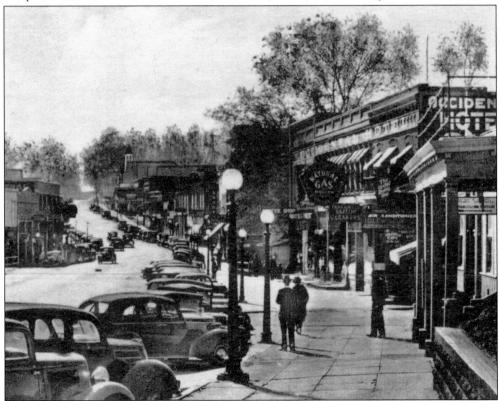

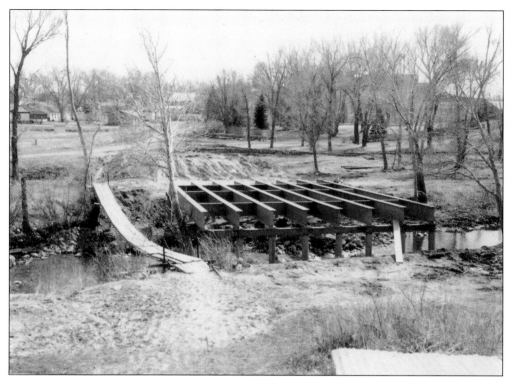

CLEAR CREEK BRIDGE. The photograph above presents an old and new Clear Creek Bridge in Buffalo. The bridge site is between the City Park and Clear Creek School. Until the mid-20th century, the only way across the stream was the swinging bridge shown on the left side of the construction in progress. The new bridge's location is on present-day Burritt Avenue, one of Buffalo's busier streets. (BBN.)

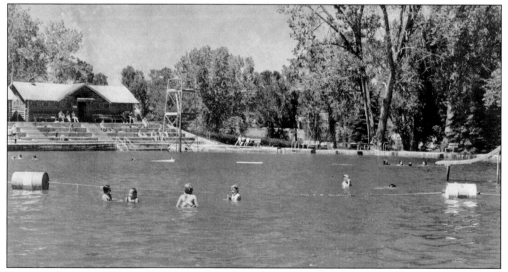

BUFFALO SWIMMING POOL. Buffalo residents have long enjoyed their oversized, outdoor swimming pool. It is advertised as "the largest in the state." This mid-1900s photograph depicts its location by the City Park. There have been periodic upgrades over the years, but admission remains free to the public. (BBN.)

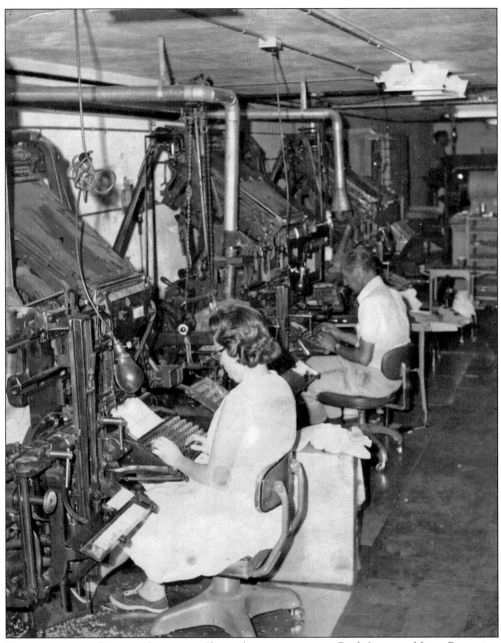

TYPESETTING THE *BUFFALO BULLETIN*. Shown here are operators Ruth Long and Jerry Browning at work on Linotype machines. Each machine that created the "lead type" for newspaper printing was said to have some 17,000 moving parts. This *c.* 1955 photograph was printed in the October 5, 2000, *Buffalo Bulletin* with a discussion concerning the challenges involved in meeting deadlines with such a complicated apparatus. (BBN.)

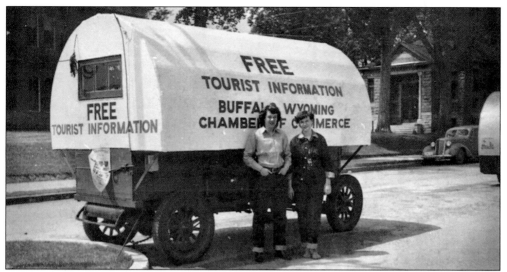

BUFFALO TOURISM BEGINNINGS. As better automobiles and improved highways became available, tourism increased in this country. Buffalo was prepared to accommodate those travelers. The photograph above depicts an early effort by the chamber of commerce to provide travel information to tourists from a distinctive, sheep wagon Information Center. During the start of the 20th century, dude ranching was developing generally in the West as some ranchers found it "easier to wangle dudes than cattle." The mid-1900s photograph below is at the Paradise Guest Ranch in the Big Horn Mountains. N. H. Meldrum began that ranch in 1907. The early visitors called the location "paradise," and the description stuck, eventually becoming the ranch's name. It continues in operation today and has its own zip code: 82034. (Both, JGMM.)

MORE GUEST RANCHES. The photographs here are early views of two mountain guest ranches, both located west of Buffalo, that have also continued to operate to the present time. The HF Bar Ranch (pictured above) was established in 1902 by Frank "Skipper" Horton and became a working dude ranch in 1911. The brand is reported to represent "Frank Horton backwards," and the ranch has its own post office: zip code 82840. The South Fork Inn (shown below) began operation about the mid-1920s. It is now named the South Fork Mountain Lodge and Outfitters. Both of these ranches offer trail rides, campfire cookouts, and guided horseback trips into the Big Horn's Cloud Peak Wilderness for hunting, fishing, and wildlife viewing that hold broad appeal to out-of-state visitors. (Both, JGMM.)

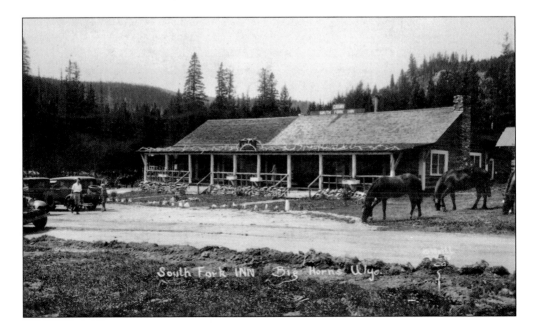

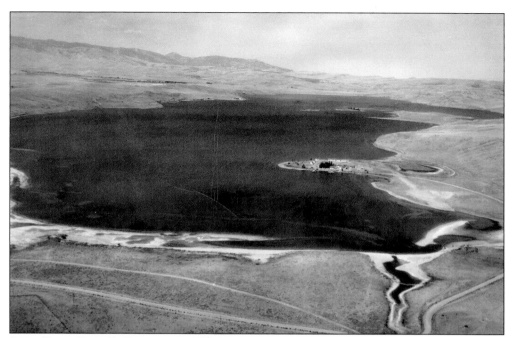

SENEY POINT, LAKE DESMET, 1950S. The Seneys are a prominent Buffalo family of multigenerational pharmacists who operated a drugstore on Main Street from the early 1910s until 2007. Ralph Seney Sr. purchased 100 acres at Lake DeSmet in 1928 that included a peninsula on the eastern shore. These photographs show the fishing and boating resort he developed there. It included an airstrip in addition to the usual lodge, cabins, and heated pool. An early advertisement referred to the lake as "Home of Father DeSmet's Rainbows." Among its prominent visitors were the actors Robert Taylor and Gabby Hayes. The lake level was raised in the 1970s, and the peninsula was permanently covered by water. (Both, BBN.)

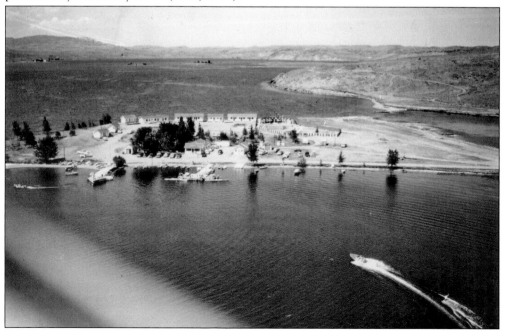

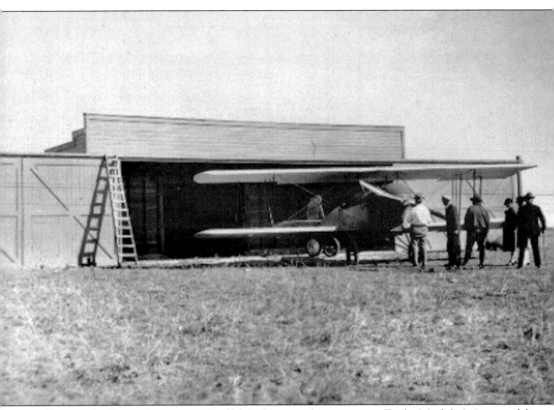

BUFFALO'S FIRST AIRPLANE. Buffalo's first airplane was an Eagle Model A-1 owned by Ralph Seney Sr. The aircraft was a three-place, open-cockpit biplane that was suitable for training and light commercial activity. It was manufactured by the American Eagle Aircraft Corporation in Kansas. It arrived in 1926 and is reputed to be the first privately owned airplane in Wyoming. A hangar for it was built on Seney land, which was eventually donated to the city. The property remains in use today as the Buffalo Airport. The Seney twins, Fred and Frank, learned to fly and were known to air-drop food supplies to remote ranchers during a hard winter. Ownership of this airplane is the reason for the previously noted airstrip at the Seney Point Resort. (JGMM.)

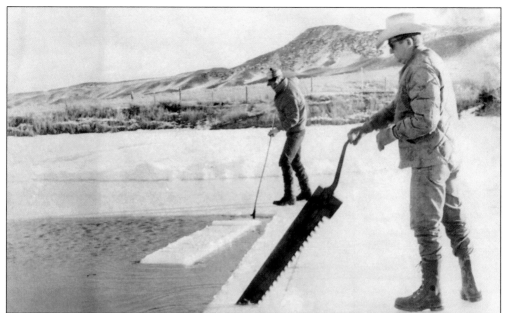

HARVESTING ICE. Prior to the availability of refrigeration, western townsfolk and ranchers would harvest a winter ice crop from streams, lakes, or special flooded areas. For example, in Buffalo, Clear Creek, the high school football field, and a 2-acre pond were so used at various times. The ice would be hand sawn into blocks, stored in a warehouse, and covered with a thick layer of sawdust from the local sawmill for insulation. Ice would then be delivered to homes and businesses throughout the summer season. The process is shown above at the HF Bar Ranch west of Buffalo. Note that the wintertime harvesting of ice dates to Colonial days in this country. Thomas Jefferson at his Monticello home in Virginia used an open, cistern-like well to store the ice rather than a surface building. A small boy would be lowered down by a block-and-tackle pulley system to bring up pieces for table use during the summer months. (Both, BBN.)

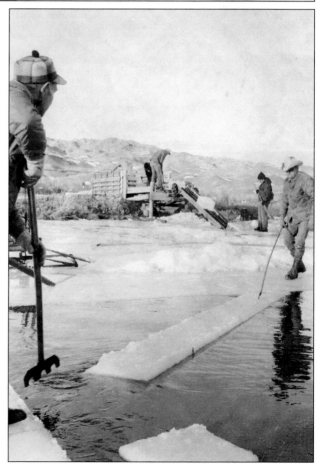

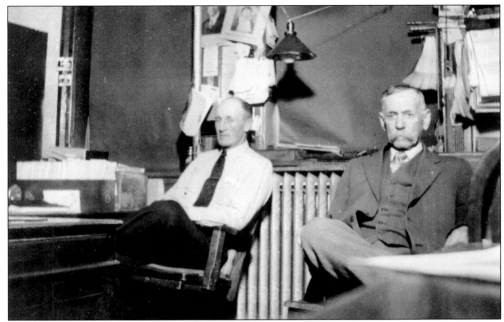

JOHNSON COUNTY SHERIFFS AND DEPUTIES. A 1938 photograph above shows Sheriff Martin Tisdale (left) and Deputy Albert L. Brock. Tisdale was one of Johnson County's most popular sheriffs, serving from 1927 to 1943. His service as county lawman is perhaps appropriate in that a precursor to the 1892 Johnson County Cattle War was the previously mentioned murder of his father, John A. Tisdale, in 1891 when Martin was four years old. Albert Brock settled in Johnson County in 1890 and was prominent in the early development of the Kaycee community there. An earlier sheriff and deputy photograph (shown below), dated 1907, shows Sheriff Frank Smith (left) and Deputy Joe Vincent. (Both, BBN.)

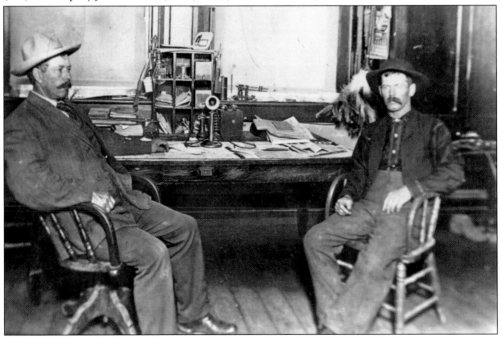

BUFFALO MINERALS: COAL. The coal deposits in Buffalo's host region, the Powder River Basin, are extensive. From the frontier era onward, settlers made use of the convenient fuel, which produced more heat from smaller volumes than wood. Some coal came directly from outcrops on local hillsides east of Buffalo (shown at right), while commercial, underground mines would produce and deliver wagon loads to town users (pictured below) at $1.75 per ton in 1910. Extensive coal purchases were made by Fort McKinney and, subsequent to 1918, by the Wyoming Railroad. From that early, low volume, local usage would develop into a major industry that became the largest single source of mined coal in the United States. The regional coal deposits are one of the largest in the world; in 2007, the Powder River Basin produced and shipped 396 million tons of coal—more than a million tons per day. (Right, JCL; below, JGMM.)

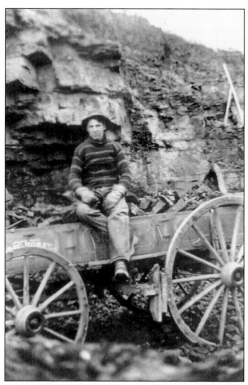

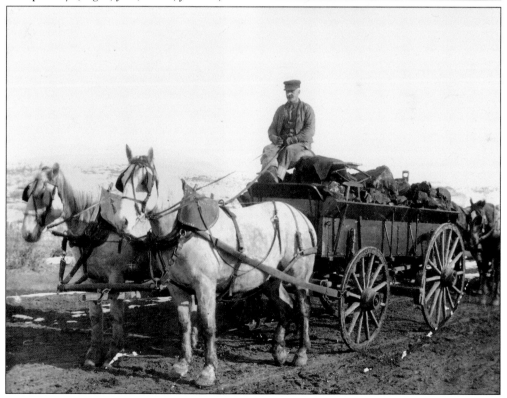

BUFFALO MINERALS: PETROLEUM AND NATURAL GAS. These photographs show a drilling rig in operation (at left) and an oil well gusher (below). They are dated from the late 1940s but have no other information. The rig was probably in Johnson County, but the gusher was likely at the Salt Creek Field in adjoining Natrona County to the south. The earliest local hydrocarbon production was at the Billy Creek Field, just southwest of Buffalo. In 1923, the Carter Oil Company struck commercial volumes of natural gas there, and by 1930, the field was supplying both Buffalo and Sheridan by pipeline. Over the ensuing decades, there were other discoveries in the area and region, and Buffalo would experience the boom-and-bust cycles that characterize the hydrocarbon industries. A regional coal-bed methane gas boom is currently underway. (Left, BBN; below, JGMM.)

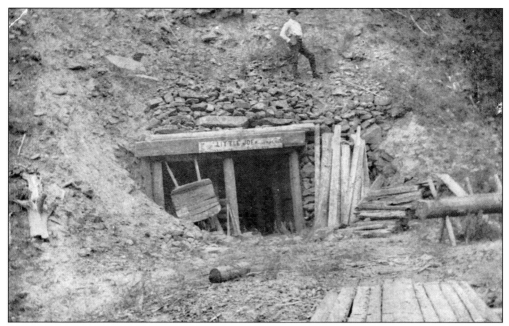

BUFFALO MINERALS: GOLD. Wyoming's largest gold rush occurred in the southwestern part of the state at South Pass near the Wind River Mountains in the late 1860s. Buffalo and the Big Horns did their best to emulate that success, but they were never even close. A well-published early rush occurred at Kelley Creek in 1895. There were also reported strikes at several other Big Horn Mountain sites, including Bald Mountain (1891–1893) and Onion Gulch (1912–1913). However, by the late 1910s, it was becoming increasingly clear that adequate, commercial-grade, gold mineralization was just not present. Wyoming historian Robert A. Murray has written, "It seems safe to say that no search for metallic minerals in the Big Horns has *ever* paid even wages to the people who financed it!" (emphasis his). The photographs shown here are of two small mines in the Big Horns, but the dates and exact locations are unknown. (Both, JGMM.)

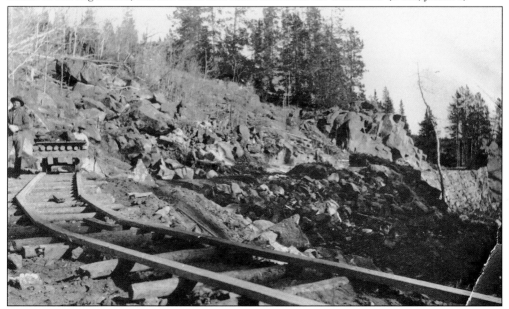

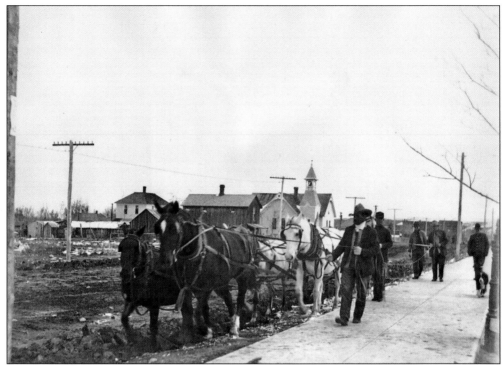

BUFFALO'S EARLY ROADS. As previously mentioned, Buffalo's Main Street was paved in the mid-1930s. However, most town streets and county roads were not hard-surfaced then or even soon afterward. They all, of course, required routine maintenance. That maintenance was conducted by early design equipment and teams of horses. The undated photograph above was labeled, "Grading in front of the school." Note that the sidewalk is concrete. The building with the bell tower appears to be the Methodist church. The photograph below, also undated, depicts road construction. What exactly the complex equipment is doing is not clear. (Both, JGMM.)

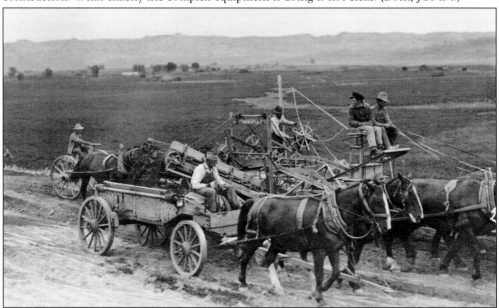

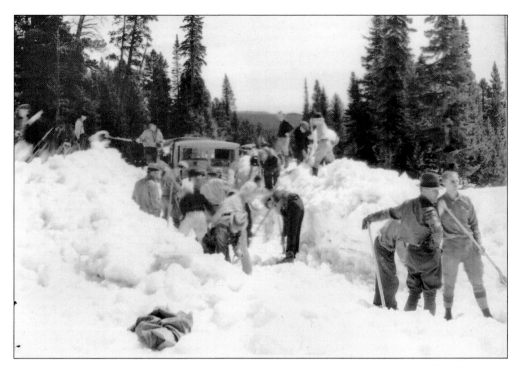

EARLY MOUNTAIN ROADS. Johnson County's western border includes a large portion of the eastern Big Horn Mountains. The mountain's weather patterns and steep slopes are a hostile environment for roads. It is, however, essential that at least some of the roads in and over these mountains be kept open for travel in all seasons. That is demanding work even today with modern machinery, but during the first half of the 20th century, it was definitely a nontrivial task. In the wintertime, there were snows (pictured above), and during the remainder of the years, especially the spring, there were land and rock slides (shown below). What would the snow shovelers have given for a modern snow plow or the rock slide workers for a large bulldozer? (Both, JGMM.)

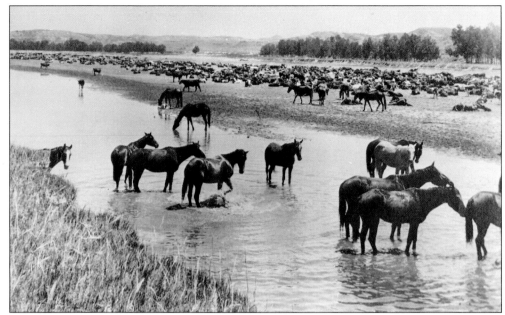

CATTLE ROUNDUP AND BRANDING. Cattle ranchers conduct spring roundups (pictured above) to gather their herds from widespread grazing areas in preparation for branding and for vaccinating (shown below). During the late 1890s into the early 1920s, there was still a large amount of federally owned range land in Johnson County that was used by ranchers. Concurrently, the acreage of privately owned lands increased until the federal government decreased the land available for filing in 1934. The number of cattle on the county ranches numbered at the 30,000 level in the 1920s. Following the 1930s Depression years, ranchers increased their herds in response to improving markets and then again for World War II demands. At the end of that conflict, in 1945, county cattle numbered more than 44,000, about 80 percent of the highest numbers during the earlier World War I. (Both, JGMM.)

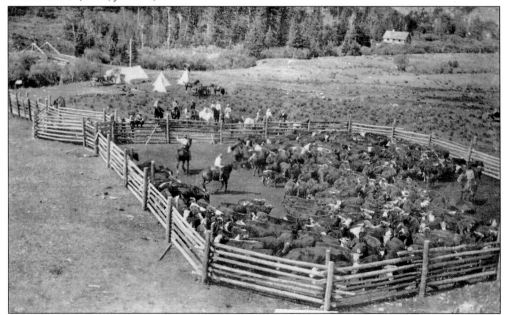

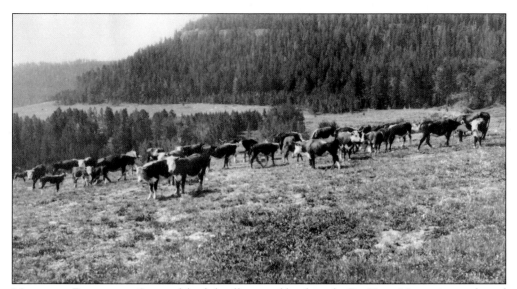

MOUNTAIN PASTURAGE. Some of the federally owned lands in the Big Horn Mountains are leased to ranchers for summer cattle grazing. This photograph shows cattle from the Brock Company Ranch grazing on a mountain range near Bear Trap Creek in 1926. Such leased acreage provides an important supplement to the rancher's own land holdings. (BBN.)

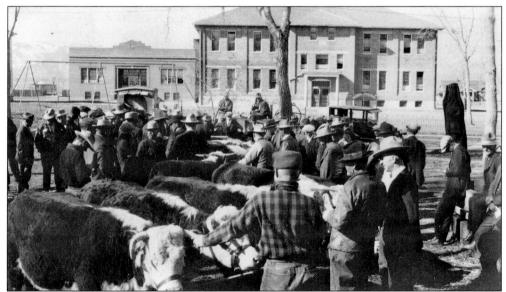

BEEF CATTLE JUDGING. Three shipments of Johnson County cattle during the fall of 1925 topped the Omaha market; that is, they brought the highest prices on those particular days. One of the many steps leading to such success, judging beef cattle, is shown in this photograph. Pictured is the annual Farmer's and Stockman's Roundup, from March 1 to 3, 1926, which took place behind the courthouse (not shown); the large building in the background is the grade school. (BBN.)

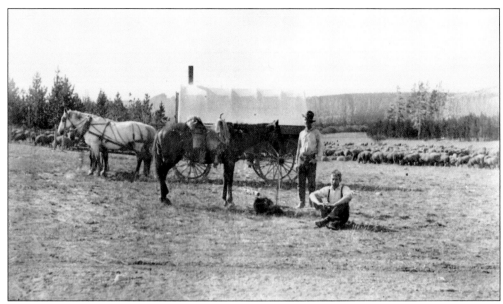

SHEEP, SHEPHERDS, AND SHEEP WAGONS. The first flock of sheep reached Johnson County in 1883, and others followed during the subsequent decade. The sheepman-cattleman conflicts that plagued much of the West during the late 19th and early 20th century did not occur in Johnson County. This has been attributed to the speed with which many local cattle outfits began to run sheep following the lead of Buffalo's H. P. Rothwell and W. J. Thom, prominent stockmen and bankers. There were 148,000 sheep in the county in 1900, up to 152,000 in 1965, and then a decline to 118,000 in 1978. Those large numbers of sheep fed on Wyoming grasses in a yearly grazing cycle from winter ranges on the prairie to summer ranges in the Big Horns. The two flocks of sheep shown here in the early 1900s are accompanied by shepherds and their unique, mobile homes—the sheep wagon. (Both, JGMM.)

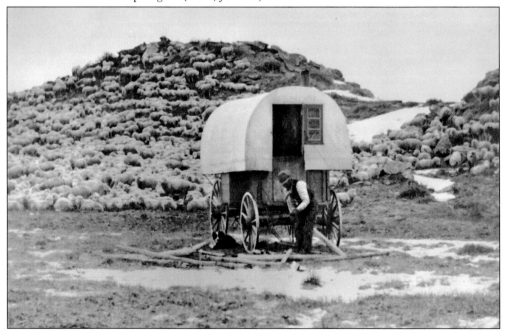

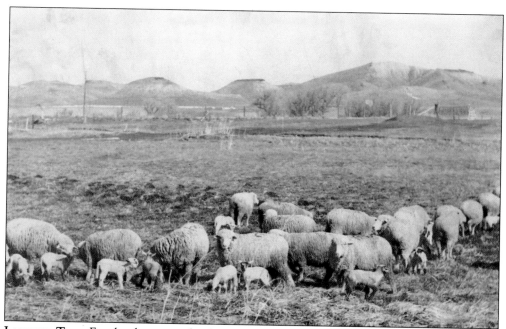

LAMBING TIME. For the sheepman, lambing time during the late winter–early spring period is a critical time of the year. It is the harvest season in the sheep business for most producers. The higher percentage of lambs kept alive, the higher the net return will be. While ewes are generally good mothers, there are a number of physical and environmental factors that can interfere with successful births, and the owner must be knowledgeable and vigilant to provide help as needed. The photographs shown here depict some successful mothers (pictured above) and some sheep owners giving nutritional supplements to a competitive group of youngsters (below). (Both, BBN.)

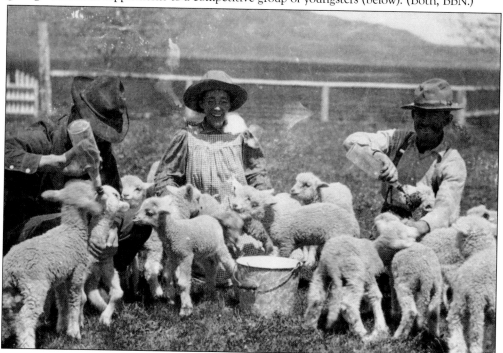

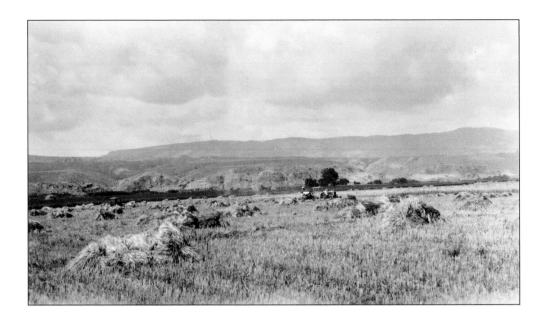

HARVESTING BARLEY. Barley is an annual cereal grain whose major market is for animal food, with minor amounts used for malting and in health food. Currently, it generally ranks fourth worldwide among the cereal crops in quantity produced and in area cultivated. It was a successful crop for Johnson County farmers in the mid-1920s. The photograph above portrays the harvesting of trebi or dry-land barley at the Brock Company Ranch in 1928. The photograph below is of Lute Porath's harvest of dry-land barley in 1925. His excellent yield that year was about 50 bushels per acre for the 40 acres he had planted. (Both, BBN.)

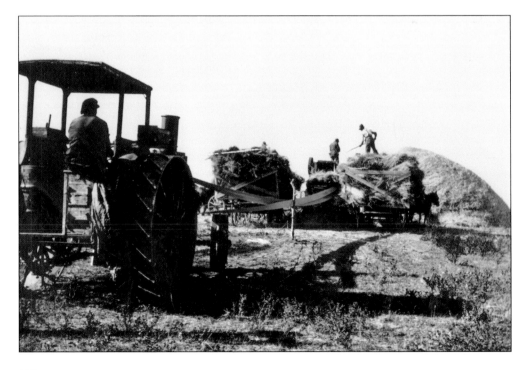

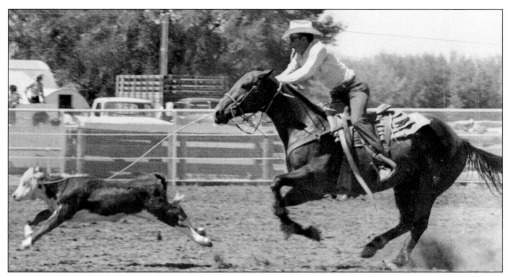

BUFFALO RODEO, CALF ROPING. Calf roping, bronc riding, and bull riding are arguably the three most popular events at a western rodeo. All three are dynamic, fast-paced events. In calf roping, a rider mounted on a horse pursues a running calf, throws a loop of rope around its neck, dismounts the horse, runs to the calf, and restrains it by tying three legs together with a short, light rope called a "piggin' string." Top professional ropers can accomplish those actions in 7 seconds, and the world record is just over 6 seconds. The event stems from the annual catching of calves for branding and medical treatment. These two photographs were taken at Buffalo's annual county fair rodeos and capture the essential actions of this event nicely. The photograph below shows the piggin' string carried in the rider's mouth. (Both, BBN.)

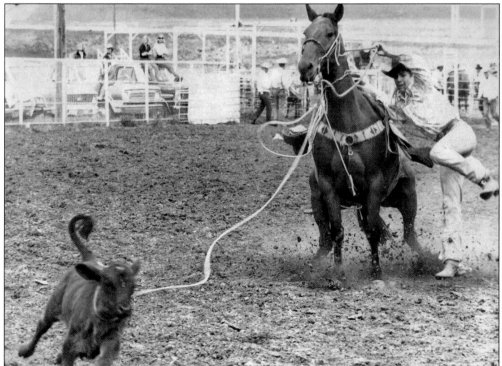

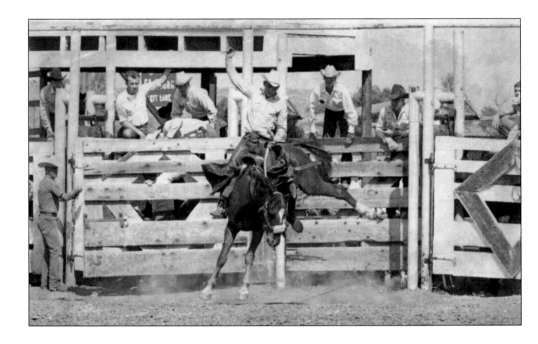

BUFFALO RODEO, BRONC RIDING. Bronco riding, either with a saddle or bareback, was a necessary skill for early cowboys to train their mounts for routine ranch use. It quickly became a favorite rodeo event. In those competitions, the horses utilized are often bred for their bucking ability, and the rider must stay on the mount for 8 seconds and not touch it with his free hand. The rider who stays on for that length of time has his riding performance scored on a 0 to 50 scale, and the horse's bucking performance is similarly scored. A score in the 80s is very good; 90s are exceptional. Above is a bronc and rider leaving the chute, and below a rider leaves his bronc. (Both, BBN.)

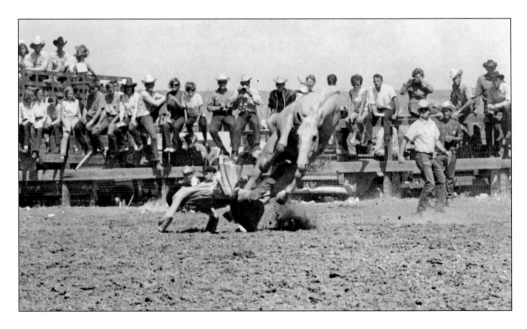

BUFFALO RODEO, BULL RIDING.
Bull riding has been called "the
most dangerous eight seconds
in sports." It is indeed that as
a rider attempts to stay astride
a powerful 1,500-pound, agile
animal that is bucking, spinning,
and twisting. The rider holds
onto a flat, braided rope that
is fastened around the bull just
below its shoulders—hopefully
for the 8 seconds required to
be scored. Bullfighters/clowns
move about the bull during the
ride trying to enhance the bull's
performance and then move in
promptly when the ride ends to
protect the dismounted rider.
Two rodeo riders are shown here.
Both are young—one a teenager
and the other just a boy. The
teenager is riding a small bull,
while the youngster is on a calf.
Such calf riding continues on to
the present as a regular event at
Buffalo rodeos. (Both, BBN.)

BUFFALO-AREA LUMBERJACKS. The Big Horn Mountain slopes, beginning less than 5 miles west of Buffalo, hold extensive stands of coniferous trees—the primary source of lumber. These photographs portray lumberjacks with downed timber (pictured above) and at lunch in the Big Horn forest (shown below). Lumberjacks are men who harvest lumber while living in camps near their work. They were often migratory, following available work, but some of those shown here could well have been Buffalo residents. While commercial logging began locally about 1910, it was not really extensive until the early 1920s. The primary demand then was from the Wyoming Railroad for ties and the underground coal mines for shaft supports. (Both, JGMM.)

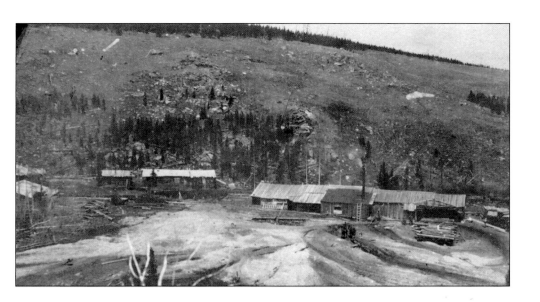

BUFFALO-AREA LOGGING CAMP AND MILL. Logging camps varied widely in their composition and size. The Big Horn camp shown in the photograph above is fairly extensive in that it has several buildings: a sawmill, a bunkhouse, a cookhouse, and probably a blacksmith shop and a horse barn. A close-up of the sawmill is depicted below. The date of photography, building identification, and the longevity of the camp are all unknown. The terms "mucky-mucks" for executives or highly positioned individuals and "hooch" for liquor are ascribed to lumberjack origins. The Bureau of Labor Statistics has listed loggers (modern lumberjacks) as holding America's most dangerous job. (Both, JGMM.)

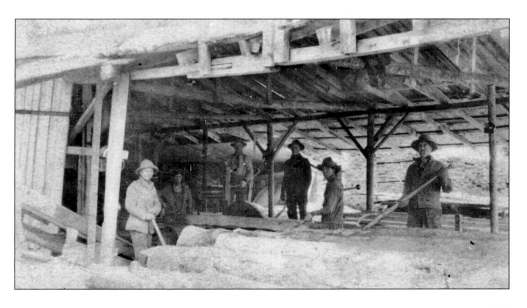

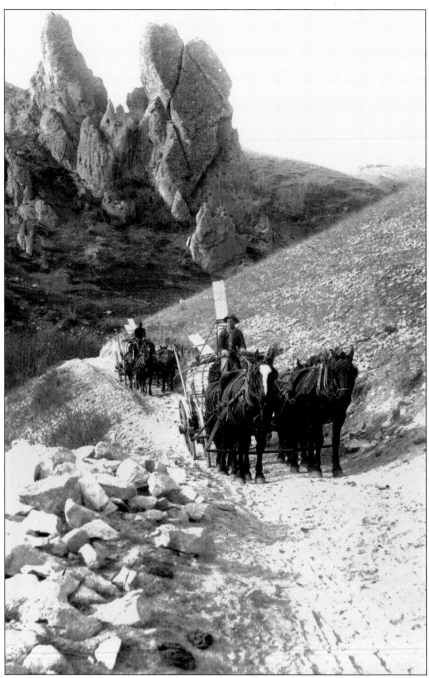

BUFFALO-AREA LUMBER TRAIN. The dimension lumber produced by the mountain sawmills was transported to Buffalo for sale in wagons drawn by four-horse teams. Usually there were two or more such wagons, and they were referred to as "lumber trains," seen here. The 1920s were apparently a peak in Big Horn lumbering; in 1922 and 1925, more than 100,000 board feet were produced by each of several different sawmills. By the mid-1930s, lumber operations had virtually ceased but were revived again for markets associated with the World War II years. Some lumbering activity continues to the present. (JGMM.)

BUFFALO-AREA RAILROAD TIE FLUME. Railroad ties were produced in large numbers in the Big Horn forest during the 1920s. The workers who produced the ties were not called lumberjacks but rather "tie hacks." The ties were moved from the forest sites where they were cut to the nearest streamside, usually Clear Creek or its tributary, Sourdough Creek, by floating in wooden flumes up to 8 miles in length. Water for that transit was supplied when needed by opening the dam on a small reservoir, termed a splash dam, which had been constructed nearby for that purpose. The photographs here are of a tie flume in the Big Horns during the spring of 1929. (Both, BBN.)

BUFFALO-AREA FLOATING RAILROAD TIES. After felling a tree, trimming the limbs off, then cutting it into 8-foot-long sections, the tie hack used a 12-inch-wide blade broadax to hew it flat on two sides to a thickness of 7 to 8 inches—a railroad tie. Because of the specialized talent and strength required for that shaping using a 7-pound, wide-bladed ax, tie hacks have been fancifully referred to as "Knights of the Broadax." This 1922 photograph depicts hundreds of such ties being floated down Clear Creek to Buffalo during the spring snowmelt runoff. (JCL.)

BUFFALO-AREA RAILROAD TIES TRANSIT. After their trip out of the mountains floating down Clear Creek through Buffalo, the ties would be collected in a holding lagoon at a Wyoming Railroad siding east of town. That scene is shown here and was enough of a spectacle that Buffalo residents would gather along the creek to watch the log flotilla in motion. From the lagoon, the ties were loaded onto flat cars and then hauled to railroad construction sites. (JGMM.)

BIBLIOGRAPHY

Bollinger, Gil. *Fort McKinney, 1877 to 1894*. Buffalo, WY: Jim Gatchell Memorial Museum Press, 2006.

———. *Jim Gatchell—The Man and the Museum*. Buffalo, WY: Gatchell Museum Association, Inc., 1999.

Centennial Book Committee, William Holland, chairman. *Buffalo's First Century*. Buffalo, WY: Buffalo Centennial Committee, 1984.

Edwards, M. R. *Duffy's Bluff*. Buffalo, WY: Self-published, 1974.

Gerhold, Mel, Ray O'Leary, and Bob Edwards. *Frontier Wyoming*. Buffalo, WY: Jim Gatchell Memorial Museum Press, 2006.

Gorzalka, Ann. *Wyoming's Territorial Sheriffs*. Glendo, WY: High Plains Press, 1998.

Hanson, Margaret B. *Powder River Country, the Papers of J. Elmer Brock*. Cheyenne, WY: Frontier Printing, Inc., 1981.

Murray, Robert A. *Johnson County, 175 Years of History at the Foot of the Big Horn Mountains*. Buffalo, WY: Buffalo Chamber of Commerce, 1981.

———. *Military Posts in the Powder River Country of Wyoming, 1865–1894*. Buffalo, WY: The Office, 1968 and 1990.

O'Neal, Bill. *Cattlemen vs. Sheepherders*. Austin, TX: Eakin Press, 1989.

———. *The Johnson County War*. Austin, TX: Eakin Press, 2004.

Powder River Heritage Committee. *Our Powder River Heritage*. Cheyenne, WY: Frontier Printing, Inc., 1982.

Sodaro, Craig, and Randy Adams. *Frontier Spirit, The Story of Wyoming*. Boulder, CO: Johnson Books, 1996.

Trachtman, Paul. *The Gunfighters*. New York: Time-Life Books, 1974.

Urbanek, Mae. *Wyoming Place Names*. Missoula, MT: Mountain Press Publishing Company, 1990.

www.arcadiapublishing.com

MAP SEARCH

Discover books about the town where you grew up, the cities where your friends and families live, the town where your parents met, or even that retirement spot you've been dreaming about. Our Web site provides history lovers with exclusive deals, advanced notification about new titles, e-mail alerts of author events, and much more.

MADE IN THE USA

Arcadia Publishing, the leading local history publisher in the United States, is committed to making history accessible and meaningful through publishing books that celebrate and preserve the heritage of America's people and places. Consistent with our mission to preserve history on a local level, this book was printed in South Carolina on American-made paper and manufactured entirely in the United States.

This book carries the accredited Forest Stewardship Council (FSC) label and is printed on 100 percent FSC-certified paper. Products carrying the FSC label are independently certified to assure consumers that they come from forests that are managed to meet the social, economic, and ecological needs of present and future generations.

FSC
Mixed Sources
Product group from well-managed forests and other controlled sources

Cert no. SW-COC-001530
www.fsc.org
© 1996 Forest Stewardship Council

Find Your Place in History.